MINGEI

JAPAN'S ENDURING FOLK ARTS

民芸

Amaury Saint-Gilles

CHARLES E. TUTTLE COMPANY
Rutland, Vermont & Tokyo, Japan

For my Grandmother,

Olivia Theresa,

whose stories of a youthful, older era fill my childhood memories. Images and tales she told have their counterparts around the world. Here in Japan my fascination with the stories behind mingei stem directly from warm and happy memories she and I shared not too long ago.

R0076522038

Published by the Charles E. Tuttle Company, Inc.
of Rutland, Vermont & Tokyo, Japan
with editorial offices at
2-6 Suido 1-chome, Bunkyo-ku, Tokyo 112

© 1983, 1989 by Amaury Saint-Gilles

First Tuttle edition, 1989

LCC Card No. 89-50148
ISBN 0-8048-1606-9

Layout by Koike Kazumi
Illustrations by Matsuura Hideaki
Photography by Sonobe Cho and Yokoi Shigeharu

Printed in Japan

CONTENTS

Preface 5
Introduction 6
Locator map 8

PREFACE

The "arts of the people" of Japan are a living, growing tradition that is a continuum of change over hundreds and even thousands of years in the case of pottery making. They are the distillation of a culture reflecting all the rich variations of the mountainous islands of Japan.

So complex is the rich variety of simple and abundant natural materials imaginatively used. Wood, bamboo, paper, straw, shell, lacquers, clay, metal, stone and other materials are transformed into delighfully charming objects of daily use. Often of a beauty unsurpassed in their quiet humility, they are useful and satisfying to the human spirit.

Mingei is a special transcultural word meaning "arts of the people." Combining the Japanese words for people (min) and art (gei), it was coined fifty years ago by the late Dr. Yanagi Soetsu, revered scholar of Japan. His keen eye observed that many articles made by unknown craftsmen of pre-industrialized times were of a beauty seldom equaled by artists of modern societies. His questioning of why this might be revealed insight regarding the nature of beauty of things which are integrally related to life and born of a state of mind not attached to a conscious idea of beauty or ugliness. Rather, it is a unified expression with no division of head, heart and hand.

In his desire to communicate this profound insight, he, together with Hamada Shoji and Kawai Kanjiro, founded the Mingei Association and the first folk art museum in Japan, The Mingeikan in Tokyo.

Many of the contemporary craftsmen whom Yanagi nurtured were later designated as Living National Treasures of Japan. Their work possesses qualities of naturalness and beauty akin to that of the unknown craftsmen of prior days.

Thus the Japanese heritage of "arts of the people" was not lost to present and future generations as is happening throughout the industrialized world. Understanding of the world significance and influence of Mingei has been conveyed through the writings of both the late English potter Bernard Leach in "The Unknown Craftsman" and the late Hamada-Sensei.

In this book, MINGEI — Japan's Enduring Folk Arts, we are introduced and reacquainted with "arts of the people" through the eyes of Amaury St-Gilles. He is a long time resident of Japan with the perspective of a sensitive and appreciative person who has come from another culture.

Martha Longenecker

Dr. Martha Longenecker
Founding President & Director
Mingei International
Museum of World Folk Art
La Jolla, California

INTRODUCTION

Folk art around the world has long captured my imagination. Whenever and wherever I visit another culture, I find it is folk art and handmade crafts that fill my suitcases to overflowing coming home. There's something special about folk art — an almost indescribable aura that makes them appear so unique. Perhaps it is merely their lack of pretensions, but I think also their attraction has to do with the obvious care with which they have been crafted.

I cannot go further without taking a few lines to express my sincere appreciation to Mr. Okada Hiromu, President of Bingoya Craft Shop and to Mr. Shiga Naokuni, President of Takumi Craft Shop. Both of these learned gentlemen unstintingly gave their time and knowledge in helping me gather information for the initial articles. Without their expert help, the essays would have been nearly impossible to compile.

And once the series had ended it was the enthusiastic support of Ms. Koko Hashim of NYC and Mr. Kai Frost of John Wanamaker Philadelphia who saw the potential of making the collection of completed essays into a book, and assembling an exhibition of folk art based on these items.

By no means should this selection of 116 items be construed as the only remaining folk art in Japan. Far from it, as there are literally hundreds from which a choice had to be made. I selected initially on the basis of location, by picking one per prefecture moving from Hokkaido south to Okinawa. Then given full rein I skipped all over the islands picking up functional crafts, toys and the more misunderstood and pervasive ENGI (literally luck bringers). These often double as toys after their effectiveness has worn out and are given to children so whilst playing they (engi) can effect their protective powers.

Unfortunately some of the items I originally wrote about have already ceased to be. The two-part production of Hatta-yaki vessels are such an example, as are the "salt-spraying whale carts" of Nagasaki-ken. And others are waning as their markets narrow, and occasionally disappear almost before your very eyes. This trend has been somewhat reversed by a renewed interest in collecting mingei spawned by regular, impressive colour layouts in popular, leisure magazines catering to the travelling middle-class. A tourism orientation to be sure, but better

than none as a market although crass commercialism of some items has done them in from that end of the scale. The biggest problem facing the makers of these unique items is teaching the craftsmanship needed for continued production to a ready and willing apprentice or relative. Many mingei have been passed from generation to generation for centuries, but the lure of a better life at better pay is creating havoc with this system.

I tried to compile this book to be as readable and useful as possible. Each item is illustrated either with a pen drawing or in a colour photograph. Most appear directly opposite written information about them, but colour printing costs forced me to gather photos together in one section. Each photograph is identified with its name and chapter number. Some items have, in addition to their illustrations, a colour plate showing special production methods, manner of use or even the way they are typically sold as is the case of Daruma. In the few instances I gave Japanese names, I listed proper family names first. And I have given the reader many Japanese words in the texts — most explained immediately and all others explained in a combined Index/Glossary at the back of the book. The locator map which directly follows this introduction is to give you some idea of the geographical spread of items selected. Prefectures are titled and chapter numbers relative to each are listed there. A guide to the colour closeups used on the cover is given with photo credits on page 260.

Meant to be compact, diverse and informative at the same time, I hope readers of *MINGEI, Japan's Enduring Folk Arts* will enjoy journeying through this encapsuled world and perhaps gain a new perspective on the value of folk art as a result.

Intervening centuries fall away when one contemplates the pathos of little Hoko-san's devotion or senses the romantic elegance of giving a raincape to your intended. Perhaps this small collection will help stem the destructive tides of change progress seems to bring in its wake, and thus help maintain the integrity of function and use that these many unique items are imbued with.

Amaury Saint-Gilles

Tokyo, 1983

LOCATOR MAP

Circled numbers refer to chapters.

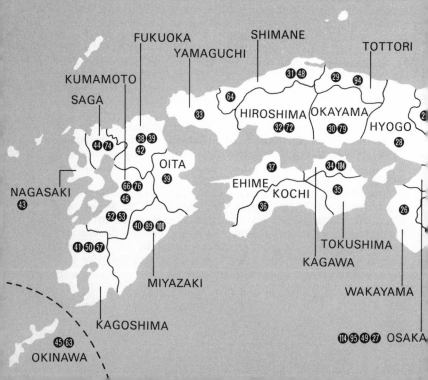

KYO

FUKUOKA

SHIMANE

TOTTORI

YAMAGUCHI

KUMAMOTO

SAGA

㉛ ㊽ ㉙ �94

㊽

HIROSHIMA OKAYAMA

㉝ ㉜ ㊲ ㉚ ㊾

HYOGO

㊹ ㊷ ㊳ ㊴ ㉘

㊷

OITA

NAGASAKI ㊴

㊸ ㊱ ㊲ ㉞ ⑩

㊻ EHIME KOCHI ㉟

㊾ ㊾ ㊱

㊵ �89 ⑩ ㉖

㊶ ㊿ ㊼

TOKUSHIMA

MIYAZAKI KAGAWA

WAKAYAMA

KAGOSHIMA

㊻ ㊿

OKINAWA ⑭�95㊾㉗ OSAKA

AINU TEBORI-BACHI

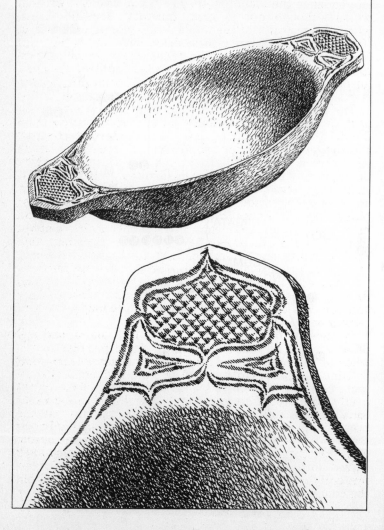

Hokkaido is Japan's youngest region, being settled by the Japanese only a century ago. To find what may truly be classified as folk art there, one has to go beyond that time period and seek work from the Ainu culture. The Ainu had long lived in this area and although much of their tradition has been both suppressed and altered since the Meiji era, they continue to create original works although not in great quantity. Several villages, where the majority of the residents are blood-related Ainu, (full Ainu being a rarity these days) have school-factories for woodcarving. Many of the designs are commercially inspired like letter-holders with a bearded countenance and a long-haired lass in traditional garb, while sculpture seldom seems to vary from a bear firmly gumming a salmon.

The problem is that both of these styles are made by a host of factories and in some cases even imported from South Korea where hand labor is considerably cheaper, thereby gaining another market edge on souvenirs. Where Ainu carvers have the distinct upper hand is in the making of exquisitely finished bowls and assorted food equipment. Items they have traditionally hand made for their own use are now being made in limited quantity for the buying public. The difference in quality between the average and most easily found souvenir carving and a bowl, perhaps like the one shown in the sketch, is like night and day. Pride in craftsmanship imbued in such a finegrained wooden bowl shines subtlely through. The soft, velvety finish inside and out, as well as the intricately patterned design on its winglike handles, demonstrates the maker's love of craft and the care with which he fashions a product worthy of respect and deserving of use.

Outside of food products like smoked salmon and any of a number of unusal flowering plants peculiar to the wilds of this northermost island, the only sensible souvenir is Ainu-associated folk art. The best and consequently more costly is hand-carved work that is functional but not overly decorated. Carved patterning serves only to enhance each object and not to dominate it. Spoons, serving bowls in a range of sizes and thick slabs of hardwood made into traditional chopping blocks, each with border edge patterning and a shallow indented keeping well carved into the flat cutting surface are available intermittently. Most such production is made for use within the community.

YAWATA-UMA

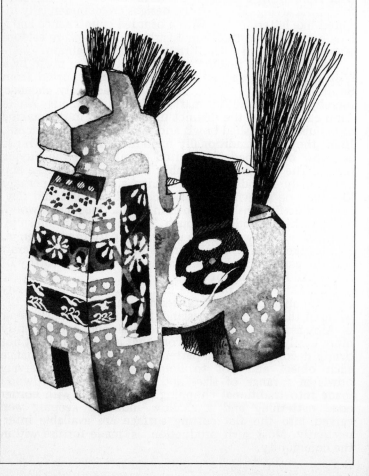

Honshu's northernmost prefecture, Aomori, has many fine examples of folk art throughout its mountainous region. Most have their origins in the hard life climatic extremes created seasonally.

Historically, YAWATA-UMA are related to feudal castle life at Nejo, a suburb of Hachinohe on the Pacific coast. Nejo samurai customs included yearly demonstrations of martial prowess in "Yabusame" contests: bow and arrow shooting at a stationary target from a galloping horse. Yabusame events were regularly held on the grounds of Yawata Jingu, a Shinto shrine dedicated to Hachiman, the god of war. These memorable occasions eventually evolved into a set festival for all area residents. Nowadays it is regularly held on Aug. 15. Scores of stalls in and around the shrine offer visitors these miniature horse mementoes recalling the samurai and their mounts of yesteryear.

The horse became a popular symbol and souvenir of the area about the time of the Meiji restoration when an itinerant woodworker settled in Tenguzawa, just to the south of Hachinohe. As supplemental income to what he earned by producing lacquerware, he fashioned a number of small chargers using only an ax and chisel. His roughly formed horses were decoratively painted and sold at the yearly Yawata Jingu festival. Popularity spurred productivity and soon many local residents were using snowbound winter days to advantage by fashioning similar Yawata-uma. Inset horse hair manes and tails add to the charm of the toys as much as does the brocadelike painted decoration which resembles the armour samurai mounts used to wear.

Yawata-uma come in a variety of sizes — from the truly minature (as big as your thumbnail) to child size. They come in two basic colors — red and black. A good guess as to why goes back to the original occupation of the first producer. Being primarily a lacquer artisan, his trade typically used these two colors almost exclusively. A nice holdover from the past.

ONI-ARARE-GAMA

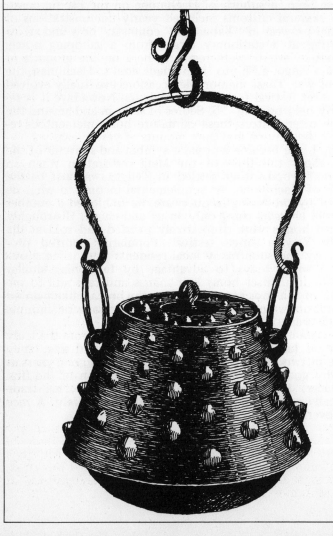

I wate-ken is part of what is logically called "snow country." Straddling lattitude 40° N, Iwate includes Honshu's furthest east cape. It is also the home for Nambu tetsubin, iron kettles that are but one of several regional folk art specialities to derive their name from the feudal clan that maintained a castle in Morioka when the prefecture was known as the Nambu district. Iron ware is made in several localities about Japan but Iwate's are the most renowned.

Iron wares have a relatively short life in comparison to many other metals but the availability of iron ore and an abundant supply of fuel made it a natural material for folk art craftsmen. Forging and casting are the two main modes of ironware production with casting used for Nambu tetsubin. This involves making a sand mold into which will ultimately flow the liquid metal. Creating this mold is time-consuming and an art in itself, the quality of the finished product dependent on the quality of the mold. Fineness of finish is determined by the inner surface of the sand mold.

Using dampened sand, the ironworker creates a negative of what he hopes to cast. Often a wooden copy of the pot to be made is forced into the prepared sand and carefully removed. The portion of the cast that creates the inner body is made in a similar but reverse manner. After it has been dried the sand mold attains a remarkable stability despite its fragile component. When the two parts are fitted together, the space between echoes the pot to be cast. To be filled with molten iron and then cooled, the completed mold is halfway to a completed vessel.

Everything from bulky hibachi to fist-size teapots are made of iron. The ONI-ARARE-GAMA shown, literally meaning "hail-stone," is used to heat water and gains its name from the bumpy knobs all over its outer surface. Patterns vary from pictorial scenes to simple but effectively pleasing decorations that barely suggest tuffs of grasses along a meandering stream.

Iwate is one place to find tetsubin in abundance and Morioka, the prefectural seat, is where one can find the widest selection of traditionally made wares. Although anonymity of the maker is a passing feature of this craft, the mingei flavor of testsubin is indelible and will last as long as Nambu wares are made.

IWAI-GERA

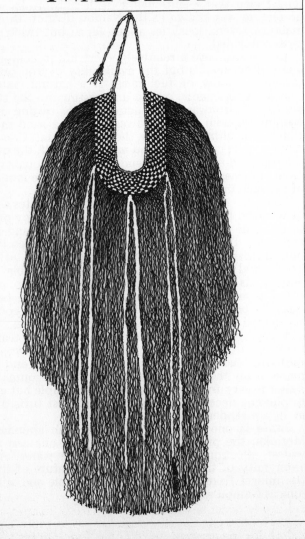

Among the many Tohoku folk crafts are a number of items using natural fibers. Everything from snow boots and bundling baskets to winnows and rain-capes are created from a variety of native flora. Most common are straw creations because this plant fiber is abundantly found as a byproduct of two staple Japanese crops: barley/wheat and rice.

Raincapes, MINO in Japanese, are found in almost every prefecture, although no two areas seem to share the same style or production techniques. Differences range from material variety through embellishment patterning to outright function. Assorted flora: rice and barley straw, sedge or water reed, join the coarse but durable crisscross hempen palm fiber as mino making materials. Bark of the Japanese lime (bodaiju) and cypress (itohiba) trees are also used but mention of flora was not meant to be misleading. Perhaps the term stretches enough to fit the tough, black-green seaweed (nori) often used in decorative tandem with one of the lighter hued grasses or barks.

Akita-ken is one of the northern areas where a peculiar-ly beautful and unusual raincape is still made and used. One finds that deep in the rural regions, customs are both respected and practiced. Mino were and are used as gifts of felicitation between men and women, marks of affection if you will. When so used, they're called IWAI-GERA. They can also be referred to as DATE-GERA or showy mino. Being attractive apparel, the iwai-gera of Akita-ken are in a class apart. A neckband of three of four colors in a pattern maintains the yoke shape of the flowing mino. The dark strands are meter lengths of sun-cured seaweed that shed water most effectively while remaining supple and useful for years. These same nori strands are used sparsely in mino from several other districts purely as decoration. The normal design has several stripes of sof-tened lime bark used decoratively against a sold back-ground of cured nori. Each spaghetti-thin strand is attach-ed to a netting of the same material to form a backing for the rainwear.

Needless to say, these mino are becoming increasingly scarce and expensive. Nothing can be done to alter this trend because the making of such mino from collecting necessary materials right through finishing, requires time, talent and considerable cost. That they survive to this day and age is testimony to die-hard, age-old customs and the support of contemporary folk art collectors. May both endure for the generations to come. Two photos appear on page 134.

ITTO-BORI

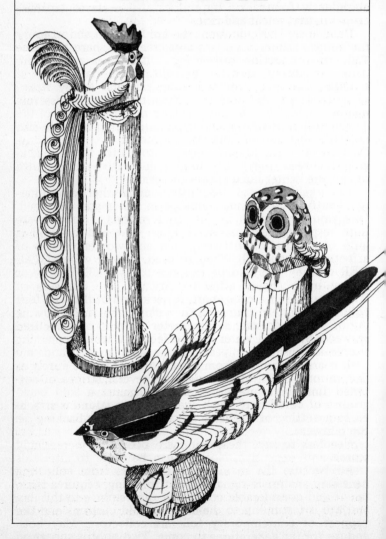

Yamagata-ken is an area rich with historical traditions. In the south of this Tohoku prefecture is a moutain called Sasano-yama or bamboo mountain. When Japan was first becoming a complete nation in terms of territory, Sasano—yama was an important frontier landmark. It was there, on the outskirts of presentday Yonezawa-shi, that settling Japanese faced the Ainu.

Divided by the mountain, the two groups lived uneasily for only a short time. About 800 A.D. Sakanoue-no-Tamuramaro was dispatched by the emperor to quell the Ainu. At Sasano-yama he prayed to Senshu Kannon, the 1,000-handed diety, for success against the Ainu and used as symbols for his plea the ITTO-BORI peculiar to this region.

Itto-bori (literally one-knife carvings) were long used to felicitate the Japanese pantheon of gods in this part of Tohoku. An indigenous shrub, aburanko, is used. The technique of carving was borrowed from the Ainu who used similarly shaved work (inau) in their rituals.

The Ainu campaign was highly successful and the emperor's military emissary eventually drove the Ainu completely from Honshu. They remained semi—isolated only in Hokkaido where today they are prominent minority.

It is not known what form the carvings he presented to Senshu Kannon took but an educated guess is they were probably a hawk with all its war-like and virile symbolism.

The traditions of itto-bori continue with what is popularly known as Sasano-bori. Soft, white aburanko is cut and well seasoned before being laid to the knife. Two special knives are used to shave single posts and achieve the feathered finish. See photos on page 128.

The assortment of birds carved these days ranges from the simple to the rather exotic — the onagadori or long-tailed rooster is a fine example of this extreme.

Careful slivering of the carving block creates an array of characteristic birds enhanced by simple surface color. Note the easily recognized line of the sekirei or wag-tail whose bobbing tail feathers can be seen at almost any summer stream.

Sasano-bori can be a perfect gift if characteristics each bird is noted for are matched to the receiver (i.e., roosters for early risers, peacocks for showy people, wag-tails for fertility, etc.) but be careful or you may lose a friend or two!

KOKESHI

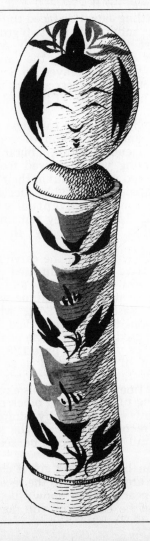

KOKESHI are probably the only mingei-hin known throughout the world. Surprising as it may seem, kokeshi have a relatively recent history. They date from the late Edo period when both leisure time and affluence in farming communities became not just a sought-after dream. Essentially a doll, the kokeshi are believed to have their origins in the practice of spiritualist religion. Dolls fashioned of most any material, including paper and clay, were thought to contain the spiritual essence of the dead and as such were often created for honorary remembrance.

Sumptuary laws surely had a creative hand in the first kokeshi's form taking. Probably it was a roughly human form turned on a handpowered wood lathe. Without decoration or face, the early kokeshi no doubt looked much like the tumbler-style wooden clothespins my mother used years ago in hanging out the laundry. The addition of decorative clothing a la simple rings of color and the expressive, even suggestive, faces that so many kokeshi wear, turned them from simple children's toys into works of collectible folk art.

Slight variations in floral and banded patterns occur with sizes ranging from 10 cm to well over 40 cm in height. Each is made from a single piece of finely turned and finished hardwood. Wood varies widely but the most generally used type is the native dogwood which is both fine-grained and light in tone as well as easily available and durable.

Probably the most well-known, Naruko-no-kokeshi come from a small community located in the northwest of the prefecture and is one of the main entry points for the Kurikoma National Park. An abundance of hot springs makes kokeshi turning all the more lucrative a winter pastime, although widespread popularity of this particular kokeshi surely demands year-around manufacture.

Early kokeshi were turned out on foot- or hand-powered lathes. Some still are, but most have turned to automation in some form for easier production. The form being so standard, lathe powering is hardly as important as the overall design and hand-decorated face and apparel.

The visitor to other regions of these isles will often find local varieties quite distinctly original from their far northern cousins. The appealing manner of these simple wooden dolls make them a favorite with all ages, hence, their strength as an enduring folk art of Japan.

NISHIN-BACHI

O f course, it isn't necessary to have such a rectangular ceramic dish to make your pickled herring in, but when the dish is almost as famous as the inner concoction, one adds to the other in the way that a well-seasoned frying pan seems to impart special flavor.

Nishin or herring come in several sizes and, accordingly, so do the Aizu-Hongo nishin-bachi from Fukushima-ken. The Aizu part of the area's name refers to its historical district name, while Hongo derives from a prominent local mountain. It is from this mountainside that the Aizu-Hongo clays are collected and the same is true for glazes used to seal the porous suyaki. Aizu-Hongo-yaki is made at only one kiln — the Munakata-gama, a 150-meter long noborigama (hill-climbing kiln) fired thrice yearly using only seasoned pine fuel. A true mingei kiln, Munakata-gama has a one-family history dating back nearly 300 years and covering nine generations.

While the kiln is well-known for these deep-sided and thick-walled storing bowls for salted or pickled herring, it produces a rather wide range of "kitchen wares." In the mingei tradition, Munakata-gama output is oriented toward functional everyday ceramics. Their sturdy appearance testifies to their endurance, while outer surface-glazing decoration is truly minimal, generally a solid shade over which may be laid some casual strokes of simply applied contrasting glazes. Typically the tone is deep brown with off-white contrasts but a creamy background is sometimes created with contrasting splashes of apple green. Everything from the massive (and weighty) nishin-bachi or wheel-thrown hibachi right down to the smallest sake-choko are given almost casual glazes which fire to multihues with smokey visual effects.

Nishin-bachi are slab-built from thick plates of clay expertly sized and fitted together. Inside corners are reinforced with additional clay strips and two basic handles pinched onto the outer ends. Simplicity from start to finish, these herring bowls are made to last. And to be used.

While Aizu-Hongo nishin-bachi can be found in almost any first-rate mingei shop, buying at the source gives extra pleasure. In central Fukushima-ken, the area bordering Lake Inawashiro in Bandai Asahi National Park is dotted with Aizu place names. The largest is Aizu-Wakamatsu, just south of which is a village called Hongo-cho where the Munakata workshop-kiln is located.

SANKAKU-DARUMA

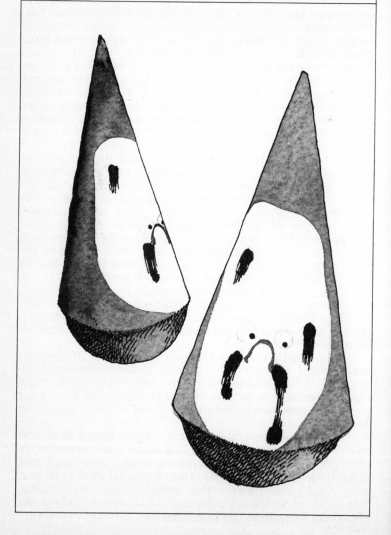

Niigata-ken typically faces wintery onslaughts fresh out of Asia. Truly "snow country" in every respect, a common winter sight is of troops of children togged out in conical straw snow capes. A group of these children trudging through snowy fields is thought to be part of the reason behind the form SANKAKU-DARUMA take. Literally "triangle daruma," these simple votive figures have a history dating 150 years.

The larger of the pair is red-robed and the mate blue while the faces of both daruma have a quizzical look with ever downcast eyes. Why the averted look? Well, an explanation for that needs some historical background. Daruma is thought to be a perversion of the Indian word for law — dharma. The doll so popular throughout Japan apparently represents an Indian Buddhist priest whose real name was Bodhidhama. After long studies in his own land, he traveled to China and the court of King Wu. When he realized that the king was not disposed to his teaching, he took leave to reside in a mountain temple at Shao-linssu. There he meditated for nine years without moving and thus lost the use of his legs (the reason why daruma dolls seem to be eternally seated in a lotus posture). The red robe that seems essential recalls the dhoti Indian monks generally wear.

It was during these long years of meditation that the priest evolved the doctrine of Zen (Dhyana) — a method of training the mind and body by quiet sitting. Zen is oriented toward making the eyes see by looking at nothing. It took a while to explain but that is the look these daruma have. Eyes that see (and know) by looking at nothing. Bodhidhama died in 536 and was buried on a nearby mountain.

Sankaku-daruma are usually bought at the first fair or hatsu-ichi of the new year in Niigata. Placed on the kamidana (household Shinto altar), they are believed to protect the family fortunes for the year to follow.

Agricultural households ask daruma's protection over livelihood crops and the successful growth of their silkworms, while fisherfolk ask daruma's indulgence to ensure large catches and safe voyages. The set from the previous year are given to the children as toys. A special game played with them involves throwing them to the ground. The first to right itself is the winner while the doll that breaks whilst playing so roughly is the loser. A good explanation why there are few, if any, "antique" sankaku-daruma.

NIKKO-GETA

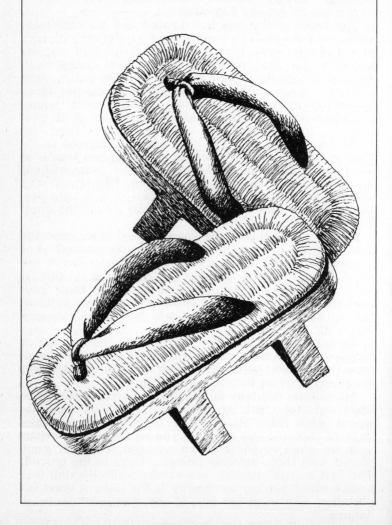

A more Japanese form of footwear would be hard to find. Geta are as common today as they were in the times when kimono were de rigueur. A man dressed in a summer weight kimono or perhaps a cotton yukata definitely needs a pair of geta to set off his clothing correctly. Socks and shoes could never do what geta accomplish in style.

Just what are geta? A form of clog or patten traditionally made from a single piece of wood. The flat oblong footrest is supported by two cross bars which keep the wearer's feet above the ground. They are kept in place by a thong which passes between the big toe and its neighbor and from there branches into two strands, which are attached to the geta's body once again near the arch. Mentioning an arch is almost a joke as geta are flat-surfaced and have no supporting features such as are common to Western footwear.

The duo depicted has a bed of finely plaited bamboo firmly attached to the upper surface of the "shoe" and are known as NIKKO-GETA. Well-known for the highly embellished Toshogu Shrine complex that dates from the early Edo period, Nikko-geta likewise date to such a time and were originally made for priests serving in the Toshogu precincts.

Besides the plaited bamboo padding which surely makes wearing them infinitely more pleasant, the thong is wrapped in white canvas. Previously, only priests were allowed to wear white thonged geta and all others wishing to have a similar pair for their own personal use had to be content with black thongs. Times change as we all know far too well, and it's a buyer's market these days. White or black, it's up to you, although the kanushi at Toshogu still affect only the white.

There are a number of other geta that have padding but only the Nikko variety uses bamboo skins. Most others use water rushes which wear through much faster.

The perfect finishing touch to a man's kimono ensemble should be a pair of these finely made and bearably useful native clogs. Even if they don't feel all that comfortable, once you tune into the clip-clop sound they make when you walk, you'll be hard put to take them off.

KATAEZOME & AIZOME

KATAEZOME and AIZOME-NO-SHIMA are two related but visibly different types of indigo dyed cloth found in Ibaraki-ken. They are both made in the same area but no longer in any great quantities as both require enormously time-consuming production techniques. The patterns created in kataezome cloth are varied and many. Many are floral and most lend themselves to unobtrusive repetition.

The printing process for kataezome involves cutting a delicate stencil from heavy washi thickened and strengthened by persimmon juices. Nowadays one can often find these stencils mounted and sold in antique shops all over the country. Even well-worn, they have a special design appeal. If the pattern is especially fine, a netting of fine threads are adhered to the cut stencil to give it added life and usefulness.

When blank cloth to be dyed is prepared, the stencil is repetitively placed over the length of cloth. Each placement is painted with a rice glue paste that leaves the cut-out pattern clearly visible. Patterns are usually cut into stencils in such a manner that they fit perfectly together when placed end to end. Usually dying is accomplished in only one indigo shade, although multiple tones can be and are used not infrequently.

When the pasted cloth is completely stenciled, it is turned into a vat of heated dye. These huge tubs are usually dug into the ground and their long use gives the dye house an eerie sense of being out of the underworld of King Emma. When the dye has taken, the cloth is washed, usually in a nearby fastflowing stream. The paste compound is then removed and voila, the covered areas have retained their original color (most commonly white cotton). A colour close up is on page 123.

Aizome-no-shima is related but this cloth uses predyed threads to create striped material in tones of indigo. The weaving plan determines the depth of color the cloth will take on in its finished state. The threads are dyed in the same huge ground-level vats that the kataezome was done in, but the threads are washed before weaving and sometimes the finished cloth is washed once more for sizing. This woven cloth is much heavier than yukata material but is still summer-weight. Fine-striped bolts are generally reserved for a man's kimono, while the widely spaced and multitoned stripes are popular for ladies wear.

MANEKI-NEKO

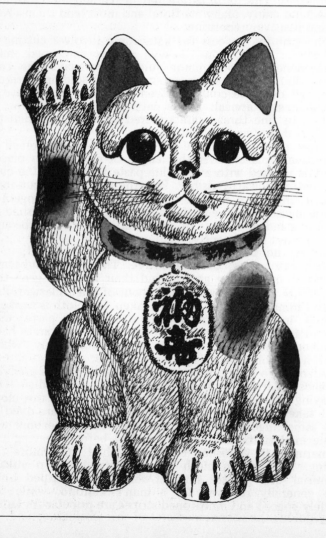

The origin of this "good fortune" symbol is based on an actual incident. Around 1800, there existed outside the gate of the Ekoh-in Temple in Ryogoku, two similar tea shops. Business was neither good nor bad but the rivalry of the two shops was still intense. To attract customers, both shops had porcelain statues of a beckoning cat made for outside their entryways. One was golden hued and the other silver. Such an unusual feature were these two cats that they attracted much attention and were often mentioned in local publications.

The owner of the one shop (fronted by the golden cat) was a layabout given to wasting both time and money. Were it not for the abilities of his charming wife, business would long before have faded to nothing. Needing money to pay her husband's debts forced this lady to borrow from an admiring clothing merchant. But the money the merchant eventually lent her was not his and by giving it away thus, he brought ruin on his trusted friend.

To atone for his mistake, he resolved to throw himself into the Sumida River from Ryogoku-bashi. As he rested against the bridge railing summoning up the courage who happens along but his vainly loved lady. He reproached her for bringing him to this situation. On hearing the full tale, she resolved to join him in shinju (double suicide) and join her lover on his journey into the other world. Over the bridge they went and the ensuing sensation caused by their dramatic deaths brought much fame to the shop of the golden cat and in turn economic ruin to its rival neighbor.

The fortune "beckoning" abilities of the cat were soon picked up on by local hucksters apparently in collusion with temple authorities. It quickly became important to buy a small copy of this cat on the first dragon day of each month. A set of 48 collected over a four-year period was required for future financial success. The hitch in this scheme (and scheme it was indeed) was that if any misfortune such as a death occurred, the collected cats must be disposed of and a new collection begun. Ever try to go through even a single year without some mishap that could well be construed as "misfortune"?

The golden coloring together with multiple collecting have been dropped in favor of single images in more natural shades — primarily a black spotted white. Next you see one of these come hither felines, reflect on why after nearly 200 years it's still drawing crowds and you just may unlock the economic secret of this fascinating land.

UCHIWA

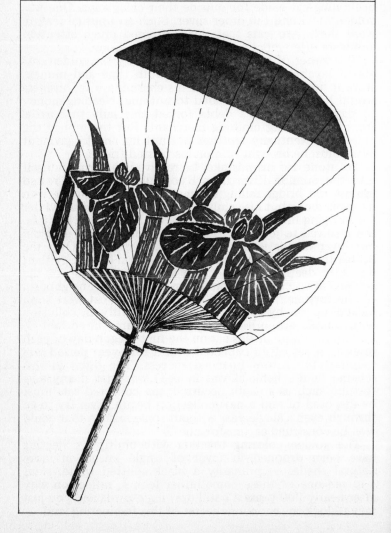

Southeast of Tokyo proper is the Boso Peninsula (Boso Hanto), one of two seaward stretched arms that enfold Tokyo Bay. The whole of the peninsula belongs to Chiba-ken and is a popular vacation spot, especially along the Pacific coastline which is a quasi-national park. The nearly year-round fair weather of the area makes it a natural truck farm arena, sometimes humorously referred to as the "kitchen of Tokyo" because it is from there that most fresh vegetables reach the populous consumer market of the nation's capital. It is also due to the exceptionally mild weather in Boso that bamboo proliferates in many varieties, from tall, thick stemmed "moso" to a slender leafy type generally used for ground cover.

Why is bamboo so important? Without the light and easy formed structure of a bamboo stalk, fans would undoubtedly look quite different. UCHIWA is the Japanese term given one variety of fan found throughout the country. Round and flat, it cannot be folded like its relative, the SENSU. Tateyama-shi, located almost at the southernmost tip of the peninsula, is where the best uchiwa are made.

Production of this handpowered cooler takes an exceptionally steady hand. The selected piece of bamboo stem will be divided neatly into carefully cut long fingers. Each is skived to brittle thinness. When these segments are spread, the basic fan shape evolves. Two sheets of durable handmade washi are prepared and it is between these two layers of paper that the spread ribs of the uchiwa are bonded in place. Paper used for Tateyama uchiwa is called tejika washi — especially strong paper that will allow long life for the finished product. A rim strip of semiprotective bamboo is sometimes slipped over the unspread ribs. This is attached to the outer edge of the paper/rib/paper bonding to give added strength and durability. A photo of production is included on page 135.

With simple stenciled patterns in one, two or three tones, uchiwa are just right for hot summer days. When summer ends they can be used to winnow rice or direct local sumo. End of fall, no trouble! Winter fires usually need some gentle fanning to help them get started, and before you know it, spring will have arrived when an uchiwa is a perfect but coy serving tray. Anyway, anytime of the year, a firstclass uchiwa can come in handy.

DARUMA

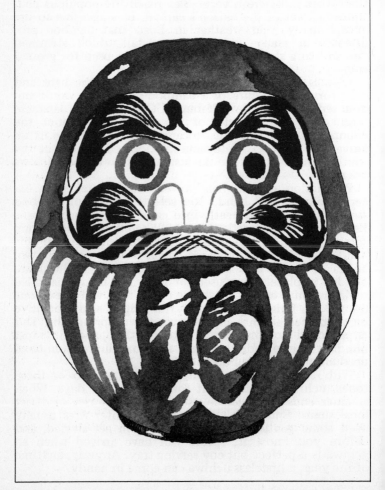

Gumma-ken is probably best known for its DARUMA. Sankaku-daruma, conical pairs made in neighboring Niigata, covered fairly well the historical background of just whom daruma dolls are though to represent. Made of papier-mache (hariko in the vernacular), strips of paste-impregnated paper are laid one on another till the basic desired shape is formed. Set aside to dry thoroughly, decorative enameling is added to create the familiar rotund, armless and legless doll. Legless he is indeed, having supposedly lost the use of them through nine intensive years of meditation but armless? Not quite! His arms are tucked coveniently out of sight in the folds of his brilliant red dhoti (Indian style robe) so he only appears to be minus both.

Gumma-daruma have blank eyes. This isn't strange at all when the whole truth is known. New daruma are always sold with both eyes white blanks as the purchaser usually wants to make a special invocation for help to the gods. When that wish is made known, one eye is painted in. This is usually done with some festivity. Many a huge daruma receive just one eye in hopes of success but, one wonders what you do with a one-eye daruma when your wish is denied?

Fulfillment of the wish creates another happy situation where amid further festivities, the second eye is ceremoniously painted in place and the daruma is whole again. His fearful countenance and whiskered face just doesn't come off with whitened sockets blankly staring. Painted in place, the doll finds its rightful place in the Japanese pantheon of gods.

One more aspect to daruma that bears mentioning is weighting at the base so that however much it veers to one side or the other, it always rights itself. Daruma of this type are also called okiagari koboshi, which literally means the bonze (monk) who gets up easily. The saying "nana-korobi-yaoki," or seven falls and eight rises stands for the try, try again spirit synonymous with the undaunted daruma.

Size depends on your pocketbook as they range from intermediate sizes to a gigantic 90 cm tall. You can get one at a Daruma-ichi (market) like the one pictured on page 131.

FUNADO-HARIKO

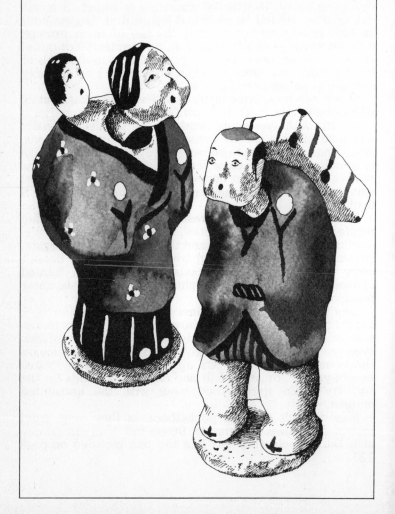

Saitama-ken borders the Tokyo metropolis and is in many respects wedded to the city. Commuters by the hundreds of thousands stream from and to abodes in Saitama daily to and from stations of work somewhere in the sprawling maze of Tokyo's streets. Being so close by doesn't especially invite the continued production of true folk art but still there survives in this prefecture a perfectly charming toy with a long history.

FUNADO-HARIKO is the vernacular name of these papier-mache dolls with bobbing heads. The variety of personages made in this type doll is quite numerous. Hariko is the Japanese term for papier-mache whatever the form. Strips of paper soaked in a rice paste solution are laid atop one another to fashion simple dolls, an exotic range of beasts and of course daruma in sizes ranging from tiny to gigantic.

Some hariko use moulds into which are pressured paste-dampened paper strips but most are freely built. A practised hand knows just how much and where to put each ready strip of moistened paper. Pinched into shape by agile fingers, the damp form is sun-dried before decorative painting is done. Simple forms take on added dimensions when the lines of a kimono are added and even the simple white band indicting a fundoshi (loincloth) helps to make the doll more real.

What really gives each doll "life" is the bobbing head which has been fashioned separately and is attached to the main body via a single string. In mobile style, heads bob and twist with the slightest stir of air currents. A perfectly stationary doll that suddenly moves must activate the awe of any child even in these days of battery-run toys. But then, these simple dolls hark back to a time when there were no batteries and even the simple clock spring key-wound toy of the late 19th century had yet to be invented.

These engaging "live" dolls are not the rough and tumble type today's youngsters are used to, but then not everything has to be handled to be appreciated. Funado is the Saitama suburb where they first originated.

HATO-GURUMA

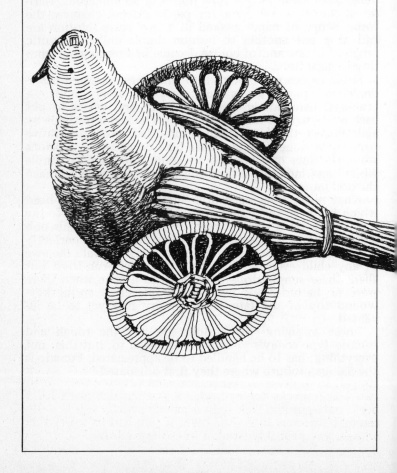

Hato in my dictionary is either pigeon or dove. Considering how the bird depicted in this folk art offering symbolizes peace as well as love, I'll opt for it being a dove.

That established, this Nagano-ken toy is called a HATO-GURUMA or dove cart. It was first produced about 130 years ago in Nozawa-shi by Anshin Kawano but production stopped after his death and wasn't resumed till nearly the end of the Meiji era (about 1900). Nozawa is in an area abounding with onsen (hot springs) and Zen temples. Many flock there all the year round to indulge themsleves in either one or the other. Visitors always want to bring home some remembrance of their travels and so hato-guruma were reborn.

The full name is Zenkoji Hato-Guruma which reads Good Light Temple Dove Cart. Whatever its religious implications, the two-wheeled woven bird is appealingly evocative of the way in which a dove pecks while eating. Loosely axled wheels gives it a rolling gait that combines with a trailing bumper to recreate a sense of naturalness. The repetitive action of searching out food that the dove and pigeon make gives them the appearance of being hard working. Hato-guruma are thus associated with industrious effort. Ownership of one of these handmade toys will purportedly bring you copious good luck and good health every day of your life. With that kind of come-on, who wouldn't want to have one just in case?

Woven of natural fiber, the current problem in Nagano (especially nearby Nozawa) is the lack of the proper vine called akebi.

The akebi's hard sinewy vine makes for durable goods of many types. Anything made from the vine falls in the category of akebi-zaiku including hato-guruma. Autumn finds collectors of this vine combing the hills. The long strands are then cleaned and debarked. It's white understrands resemble raffia, and likewise are made easily pliable when put into water for a short time. They are woven when damp.

Hato-guruma come in two sizes, the smallest easily cupped in your plam, while the largest is lifesized. With two black specks for eyes and a sharpened branch for a beak, hato-guruma lack only a pair of spindly legs to fully resemble the real bird. But then, if you had two very fine wheels, you probably wouldn't need legs either.

KOMA

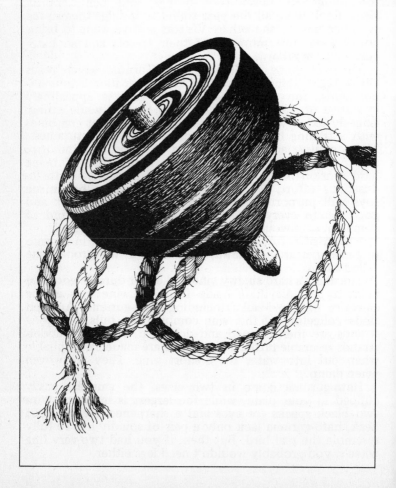

Not far into Kanagawa-ken lies the village of Isehara where Oyama koma are made. Koma means top, and there probably isn't a country in the world where spinning a top isn't part of a child's growing-up memories.

In Japan, the number of top styles figures nearly 100. The differences are mainly in painted designs, much like the major differences between kokeshi is not in their shapes but rather their painted stylizations. The Oyama koma is a rather sturdy type having a large solid wood disk with two protruding spindles. The upper portion is where one loosely attaches the spinning rope while the lower one is a spinning point upon which the weighty top will dance madly to its own circular patterns.

There's something about the balanced, circuitous dance a top follows to its final anxious twists. When it finally does stop, hardly anyone can resist giving it another throw to start it off once again.

All of my childhood tops were plain colored and the excitement of seeing them spin was more in knowing what they were doing than in actually visualizing the movement. Japanese tops tend to have patterns of concentrically painted, multicolored circles. Oyama tops offers a broadside view of rich purple while its top has assorted circular widths of red and purple. The thick hemp rope is perhaps one of the more surprising aspects of the Japanese top and no doubt one of the hardest-to-master features. The dexterity of small children with such a bulky rope amazes me yet.

Formerly, tops were popular gifts at New Year's (shogatsu) when the children had to play inside more often due to the harsh weather. In fact, a children's song sung prior to the coming of shogatsu used to wistfully dream of new spinning tops and hoping the days until the holidays will quickly pass so their new toys will be in hand.

If you get a top whilst traveling, you'd best get some expert instruction on how to properly wind it and set it going its merry way. It's no do-it-yourself trick and the frustration of having it constantly falter, instead of dance as hoped, is enough to make one cry.

Koma come in all sizes but most are at least fist-sized while many are a great deal larger. Almost without exception are they ovoid and smoothly finished.

KOSHU-INDEN

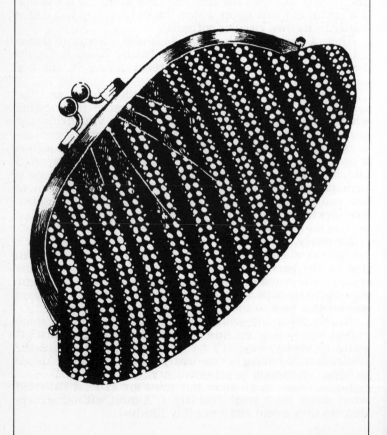

KOSHU-INDEN is made of softened deerskin onto which has been stenciled a thick design of lacquer. The Koshu portion of its name comes from the former designation given the prefecture now called Yamanashi-ken.

The making of this peculiar art work dates back 13 generations (and perhaps even farther in other areas.) Some of the earliest examples of this lacquer strenthened leatherwork is to be found in yoroi (ancient Japanese armor). Large plattens of deerskin and sometimes pigskin were thickened and thereby toughened by coating the outer surfaces with fine designs of colorful lacquering.

When armor was widely used, production of inden was rather widespread. The end of the warrior era forced many inden makers to either quit or find new outlets. Yamanashi makers turned to the production of inro or cases for medicine and/or personal seals. These items became much sought-after for their unusual styling as well as their serviceability. Yamanashi makers kept abreast of the times and as changes in style and need occurred, production of related inden articles took new directions.

The drawing shows a rather finely decorated change purse. The tiny white dots respresent its lacquered design while the black background is a very soft-to-the-touch dyed buckskin. Lacquer coloring resembles the variety of the spectrum although only one shade is used on a single work. The backing leather is similarly dyed in single tones and the combination of the two colors is usually a most compatible contrast.

The range available these days tends to be an assortment of bags — from small pouches for hanko through change purses shown here to large handbags with pullstring closures. Several sizes of wallet along with comb, meishi and teiki cases make up the current goods available in traditional Koshu-inden.

Practical and lightweight, inden is a modernized mingei with an undeniable link to Japan's romantic historical past. Simplicity and function — two inherent aspects of folk art that are surely applicable to this 20th century updating.

YANAGI-GORI

One has to have lived long in Japan to have memories of this folk ware. Almost every family looked forward to the annual visit of the medicine peddlers from Toyama-ken who came with a rather huge but extremely lighweight box of supplies on their back. The trunk along with its inner goods are traditional products in this Japan Sea coast prefecture originating near and in the city of Toyama itself.

Made of willow wands with edges and corners reinforced with strips of cloth or lacquered leather, the broad expanses of willow are woven on the same type loom used to make goza (tatami coverings) but differ in that warps are spaced farther apart. They are occasionally four-hettle loomed allowing the weaver to create intricate patterns dependent on the spacings of both warp and weft.

To get back to the medicine peddler, they usually made a set round of villages visiting each home at about the same time annually. With a large furoshiki of green and white covering a payload of medicines, their yearly arrival was typically announced by a chorus of village children singing any of a number of nonsense songs, some quite rude, about Toyama kusuri. Unwrapping his main YANAGI-GORI (willow wand case), he must have seemed to be some kind of magician to the children crowding around when an array of ever smaller willow boxes was displayed. The housewife usually brought out that particular kusuriya-san's company bag which hung in a closet and had the goods used over the past year replenished. Medicines used were tallied up and charged for as well as replenished. Trust was an integral part of both the sale and the use of this style medicine.

One reason why children seemed to look forward to the peddler's visit so much probably hinged on the rather unusual paper balloons they passed out, as appreciated and looked forward to as shogatsu koma.

Unfortunately, the whole style of peddling Toyama medicines has altered greatly with the economic resurgence of modern Japan. The peddler no longer trudges or bikes from village to village nor does he leave a black paper medicine sack, this having been replaced by convenient plastic bags. The willow wand cases with all their inner compartment boxes too have gone and one finds this style box only as a storage case for summer/winter clothes in homes where tradition dies hard.

TAKO

A *kite*
in the same place
in yesterday's sky!

This Buson haiku (translated by Blyth) captures the floating freedom one naturally feels on seeing a small wisp of paper and bamboo sailing lightly aloft, tied to land only by the thinnest cord. The East is famed for its variety. Crowded Edo spawned miniature varieties flown on slim threads, kites smaller than the size of a modern calling card. Other locales created monstrous behemoths that required a steady breeze and 40 able men to send them soaring skyward and to keep them aloft. The inbetween ranges run the whole gamut in sizing with washi and take as materials. Kite makers talents are slowly being recognized as worthy of propagation.

Not to slight any locale, this chapter is concentrating on just one particular kite — the fighting kite of Hamamatsu in Shizuoka Prefecture. For three days every spring a kite festival brings thousands of spectators and hundreds of participants from all over Japan. Kites used all resemble the one pictured, although their visual design varies greatly. Huge kites often have a single complex kanji. Others use crests (mon) and some pictoral representations such as the Japanese crested crane, symbol for happiness for over 1,000 years. The kite shown has the katakana "na" as its sole pattern. No doubt size (paper face being about 70 cm square) dictates the simpler design but some small kites are vertitable works of art with intricate patterns.

Formalized fighting, pitting one district agianst another, was the final outcome of restrictive regulations on size and decor. Limited on two fronts, flyers turned to fighting style to express their enthusiasm during the May fete. By friction of string on string, one or more bridle cords holding the kite to a stable flight position will snap. Uneven pressure will then break its remaining holds, causing it to run free and fall. The winning team is delirious and the losing team anxious to repair their fallen wonder for another try. A related photo is on page 129.

BANGASA

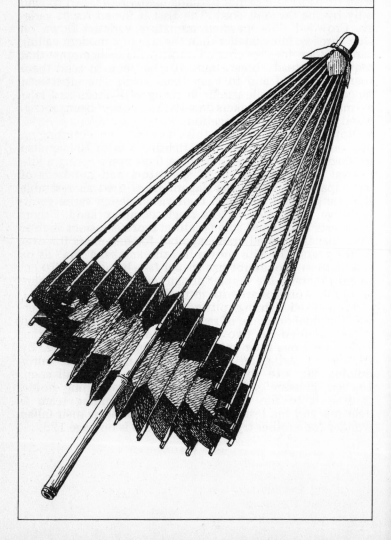

Nothing seems so lovely as a kimonoed lady sheltering from the rain under a BANGASA. Light filters through the translucent covering and delicately illuminates its sheltered user. These lightweight items are a speciality of Gifu-ken where both abundant varieties of versatile bamboo and handmade paper are readily available. It's no coincidence that makers of these umbrellas are also typically makers of chochin or paper lanterns, the materials being identical.

Bangasa come in at least four varieties. There is a thick-handled and sturdily ribbed man's model, a thinner, more feminine style for ladies and a child's size. In addition, there is the brightly tinted slim style favored by refined ladies and geisha. All are essentially the same construction with hinged bamboo ribs that use horsehair threads to secure them firmly in place. Horsehair is also used to reinforce the paper covering, being glued into folds of the paper along the edges.

One difference readily apparent is the halfway stop ladies' bangasa have. When the rain pelts down, a halfway stop allows the owner to cock it open in a conical position that hugs head and shoulders more closely.

Another distinguishing feature are the number of ribs. Men's usually number about 50 while ladies' typically have 40.

The previously mentioned four types must be expanded if one includes the HIGASA, surfaced with fine silk and meant only to protect the user from the sun's heat. The *hi* in it's name derives from the kanji for sun.

SHUGASA are yet another variety that should be mentioned, although they are not to be seen on the street. These huge umbrellas are used for shade in garden tea ceremonies. Commonly a bright red, their two-meter plus diameter of crimson casts a large shadow.

First mention of the ribbed-style umbrella dates to the reign of Emperor Kimmei (539—571) when the King of Kudara, a large province in Korea, sent as tribute several finely decorated silken kasa. Prior to that time, large reed hats were widely used for rainwear.

They are still extremely popular at most traditional ryokans who stock them for patrons when it rains. These kasa are often adorned with the name or mon of the inn decorating an otherwise plain style. See page 130 for two related colour photos.

WAJIMA-NURI

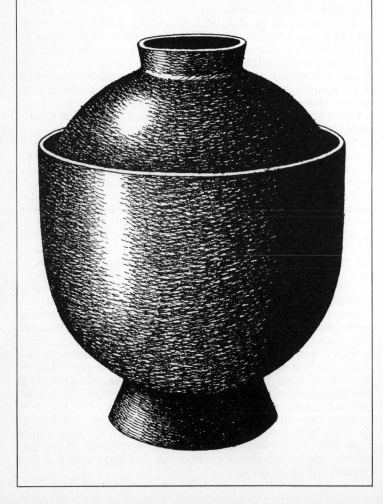

S hikki is the correct Japanese term for lacqueware, al-
though a great many varieties of the same exist
throughout Japan. Prior to upgrading of kiln techni-
que in the early 17th C, lacquering was the most widely
used medium for food vessels. The advent of cheaper seto-
mono caused a decline that finally took its toll of a cottage
industry whose small scale production could not compete
on the level of the newly improved ceramics centers.

WAJIMA-NURI derives its name from where it is made
on the Noto peninsula in Ishikawa-ken. Nuri is a conjuga-
tion of the verb nuru which means to paint. Similar place
names are applied to other extant lacquerware centers scat-
tered thinly about the islands.

Most are identified by some distinct design
characteristic. Tsugaru-nuri (often referred to as baka-
urushi or foolish lacquer) is easily discerned by multihued
crazed patterns. In Iwate, where the Heian-era stronghold
of the Fujiwaras flourished, is found still a style dating
from those exuberant days laced with gold leaf in elegant
but classic motifs.

Another northern lacquerware is the wood-grained
variety found in Sendai, Miyagi-ken, which differs from
the wood-grained Shikoku style in that the wood is com-
pletely covered on those from Tohoku while the Kagawa
type uses natural wood colouring to augment an overall
design of concentric circles.

Nara has yet another type one can easily recognize —
red patterns painted over black backgrounds. But all con-
trast readily with Wajima-nuri's simple, straight forward
forms and solid tones where black outer surfaces are
generally lined with inner surfaces of red and vice versa.

It is reassuring to know that in Wajima wood alone is
used. Icho or ginko wood is favored, although many types
are used. It seems the ginko tree is lightest and strongest
as well as easiest to form into thin walled pieces.

Lacquering takes months for the finest pieces — some-
times a full year between the first lacquer application and
the final layer. As many as 12 and occasionally double that
are not uncommon but cost well reflects what you are
buying. Two related photos are on page 132.

MARUBASHIRA-YAKI

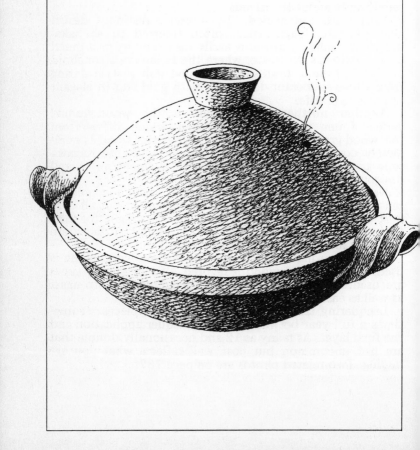

Marubashira, Mie-ken gained its name from the huge wooden pillars it supplied to the Nara court. A small sleepy hamlet then, it hasn't really changed all that much in the intervening years. What has changed is that the village is no longer known for massive timber posts. Its present fame rests on ceramics that have been the villagers' production mainstay for several centuries.

Marubashira donabe are well known throughout the nation. Dobin (ceramic teapots) glazed a lovely bluegreen share the spotlight with the glazed, buff-colored cooking pots but are made at just one kiln.

Fukumori-gama is the lone holdout for tradition in this valley with a half-dozen-plus potters under the direction of the kiln's master. A close look at the majority of the lidded pots put out by the many villagers who pot for their livelihood shows moulding and jigging are rampant. Only the Fukumori workshop creates its whole line on the potter's wheel. The similarity of most donabe coming out of the village is offset by the lovely forms and hand-finished fillips given works by the Fukumori potters.

The young master of the kiln is an expert cook. His personal conviction is that fine cooking ware adds considerably to the art of good cookery. It won't make poorly prepared food tasty but it will heighten the pleasure of eating any well-made meal. So his kiln regularly produces variations on the standard donabe. Shapes and glazes custom-crafted to form an assortment of cooking vessels that fit contemporary cookery: high-sided casseroles, low teppan-yaki dishes with roomy lids, shallow-lidded pans and deep bowls with wooden covers. Decorations are minimal and glazes used tend to earthy hues.

Clays and glazes are locally collected and refined at Fukumori-gama. The kiln master, heir to several centuries potting heritage, is trying to continue the better aspects of his craft while changing those portions that bear improvement. Form and glazing are two areas that constantly need updating. Not everything left to the present from days long past is as functional now as it once was. Improvements fostered by this kiln, while maintaining traditions of craftsmanship and function, bring this mingei pottery into active touch with the 20th century.

HATTA-YAKI

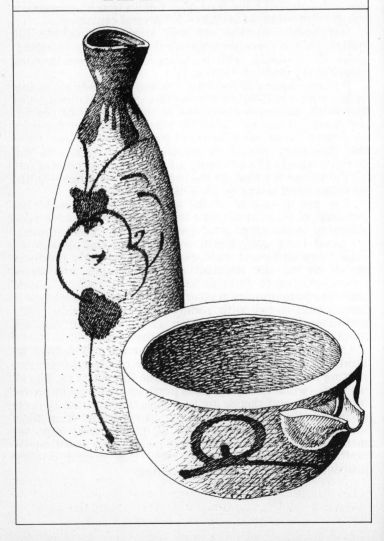

Shiga-ken skirts the shore of Lake Biwa and melts into mountains that literally cover the whole of the Kii Peninsula. Hatta is a quiet little village of level paddies where one can easily find the kiln of Juji Miyaji. Hatta-gama (fired jointly with a nephew) sidles up the hillside above his home, the fire pits handily convenient to the overhanging porch of his aged workshop.

The illustrated examples demonstrate the full range of wares made there. All sizes of both TOKKURI and KATA-KUCHI are made, each with the distinctive plum flower pattern in iron underglaze.

Tokkuri (sake warming and serving bottles) are the most interesting ware he creates mostly not for the liquid it will someday hold but for the unusual potting manner used to form each one. Throwing off the hump as do the majority of the Japanese potters, Miyaji-san throws countless upper halves slicing each from the spinning clay mass when it reaches the right size. When he has handy stock of these "uppers" on a rack board, he begins to fashion lower halves off the same spinning hump of local clay.

Using a measuring device aptly termed a "tombo" or dragonfly, he forms a cylinder that exactly echoes the "uppers" diameter. That accomplished, the wheel is stopped while an "upper" is deftly fitted to a "lower." The wheel is slowly started once more while an egote is thrust through the neck of the vessel to aid in sealing the two parts together. Outside fingertip pressure and inner pressure from the forming tool's knob binds the seam and makes the two cylindrical halves one.

String-sliced from the wheel and set onto a drying rack, it is given a spout-forming pinch before curing for a day or so. Bottoms are then trimmed and the next steps are bisque firing, underglaze decoration, overglazing with a translucent white and final firing. Voila, rows of red-topped raw-glazed sake-warmers become rust-capped and flower bedecked warm grey.

Katakuchi (used to measure liquids) are made in single throws with the spout taking a little extra work. No rusty caps but plenty of flowers — the same sort as have been decorating these mingei ceramics for the past three centuries.

Miyaji-san died shortly after this was first written (1978). Hatta-yaki is no-longer made in this manner although a neighboring village kiln is recreating the style.

KAMA & NIGIRI-BASAMI

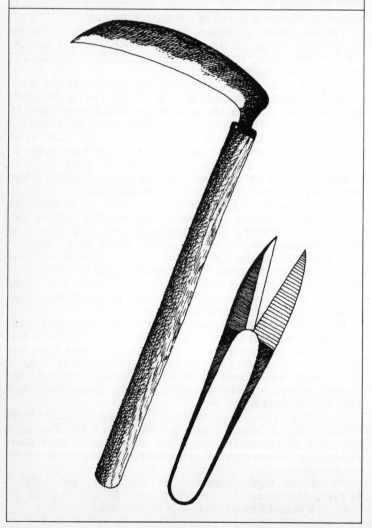

First-time residents in this land of contradictions soon become addicted to learning about such "reverse" logic wherever it is applied. Tools create a heaven of discovery with saws that pull instead of push and planes that do likewise. If one's view extends to field tools, you must come to grips with scythes that pull instead of sweep when they slice and clippers that squeeze instead of cut with fulcrum leverage like Western scissors do. Why? Your guess is as good as mine. Instead, one (if you intend to live here for any time) comes to grips with the movements of these implements or you buy Western imports more familiar in shape but outrageous in price.

The hand scythe shown is a grass cutter. One hardly ever sees a reel-type mower, although they are available. Grass lawns are hardly a widespread phenomenon and small border trimming and weeding is done with this hand cutter. That means you must be stooping to ground level to work it and work is just exactly what it is. Hard work!

Blades come in a variety of curves with the longer ones used primarily for weed control while shorter shanked types are used to remove not just the greenery but also its root system. Those used harvesting the fall bountry of rice are notched along the cutting edge much like the wavy slicing edge of an expensive bread knife.

Scissors are found in an equal range of sizes. Huge clippers fashioned in exactly the same way as this tiny pair are used for chopping on farms. Everything from vegetable greens to be discarded or fed to domestic animals to trimming hooves. Inside one is sure to find several pairs including a sewing basket that wouldn't be complete without a sharp pair of hasami.

Fukui-ken is known throughout the nation for production of these fine iron tools. Hand-forging is nearly a forgotten art elsewhere but pockets of activity still exist in this mountainous prefecture fronting the Japan Sea. The finest blades are signed with the signature markings of the maker both on the blades and on the handle. Scissors too are often etched with the maker's trademark. Little of the iron ore used to create these blades is mined in Japan any longer, but the workmanship and pride imbued in each is easily evident in the manner in which they are both displayed and cared for, from shop to home — right where mingei has its roots.

SENSU

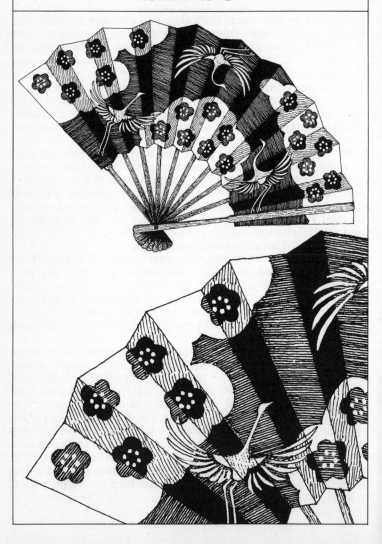

One runs into mention of fans on almost every other page of ancient poetry collections and court-life chronicals. A recounting of the story of the invention of SENSU may be of interest (even if it has to be believed with more than two or three grains of salt).

The widow of Atsumori Taira (son of Kiyomori, the central character in *The Tales of the Heike*) retired to a rural Kyoto temple to grieve and mourn her loss. The temple was Mieido where, as a nun, she long resided practising her devotions and trying to better the lot of her fated young husband. While in residence, the abbot of the temple fell ill with a raging fever. Atsumori's widow ministered to his sickness and with a folded paper, she tried to cool his fevered head. Days of fanning the sick man whilst muttering incantations seemed to effect a cure and the recovered abbot was very grateful.

The fan-shaped simply-folded paper she used to cure his illness was soon turned into the stick-supported fan one sees so often today and the priests at Mieido were/are thought to be especially adept at making these fans. Even today, one finds many shops dealing in fans named "Mieido" in luck-bearing appreciation of the originating temple.

The convenience of folding fans makes them a favorite with both sexes during the humid summer months. A good light-weight folding fan (of suitable design, of course) is worth its salt (leftover from believing the invention story) on a hot train ride or anywhere where elbow room is to be had.

Folding fans are used in traditional theater in a variety of ways. Some are accessories for dancing taking on the guise of letters to be read, cups brimful with sake to be drunk and partitions to be hid behind. Such use of fans takes long hours of practice but when one sees such illusionary expertise in action, the fragile beauty of the whole dance routine is heightened.

Folding fans are also used for emphasis by Rakugo and Noh actors but outside the theater, one finds another unusual aspect to fans. They mark esteem and are given according to your inclinations toward someone special. Most young people these days would be mystified by so subtle an approach. Still, as long as the delicately splayed bamboo and paper folding fan is made, this holdover from another era won't lose its imaginative charm.

KUJIRA-BUNE

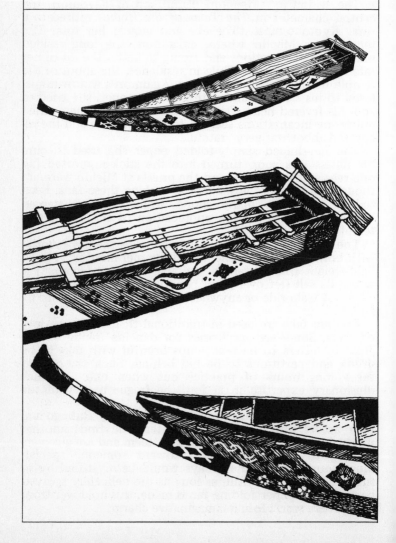

W orldwide hue and cry about the slaughter of whales has little to do with this folk art item, but has very much to do with whales nevertheless. KUJIRA-BUNE directly translates as whaling boat. These 8 to 10-meter narrow rowing craft no longer swarm off Wakayama-ken but in days not long past, the seas there were rife with such small boats in hot pursuit of the worlds largest mammal — the whale. The village of Taiji in particular was especially connected to this industry so deplored today. The whys and wherefores follow.

Some 400 years back during the Hojo wars, a samurai on the losing side fled to the small fishing village of Taiji. Asahina-Saburo-Yoshihide could no longer ply his hereditary work, so he sought to create a new job for himself which would not only bind him to the lives of the impoverished fisherfolk but would also be of long-time benefit to all (including himself, of course). His idea was the hunting of whales which seemed to be populous in the seas nearby.

Everything from design of the catching craft to the manner of hunting had to be devised, and credit is now given liberally to that one man. The ships themselves are now only to be found in a museum devoted to whales in Taiji-cho. Outside of those displays, one must settle for replicas painted to echo times long past.

They made three varieties of whaling boat. Seko-bune were the harpoon or catch boat like the craft illustrated. Koroshi-bune were the boats that closed in for the kill once the whale was secured to a harpoon line. Broader of beam, they lacked the streamlining seko-bune needed for the initial attack. Mosso-bune were the boats used to bring the whale to shore. Often these last type were lashed together to create a catamaran style system between which the whale was maneuvered. All of the craft were brightly painted with felicitous symbols and colors. Since one wasn't always out on the seas in search of prey, the hours were whiled away improving the boats' design and vying with one another for decorations. These decorations extended to regular fishing craft too!

It might be noted that Taiji's museum and attached aquarium are the only such complex devoted solely to the study of whales anywhere in the world. A plus for the Japanese who are repeatedly cast as bad guys in the depletion of the world's whale reserves.

SUMIYOSHI-ODORI

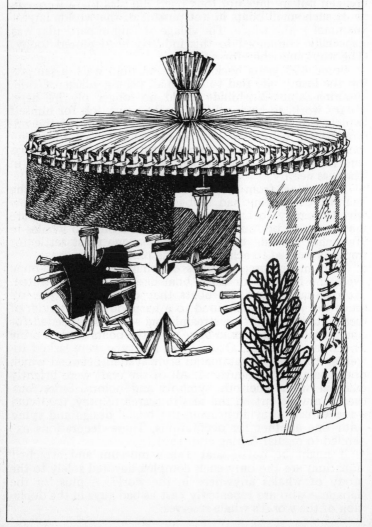

By droves do people flock to their favorite shrines when special festivals are held. Besides enjoying the happy atmosphere, festival-goers generally acquire at least one memonto of their visit. In Osaka, one of the largest shrines is Sumiyoshi Taisha — whose long and impressive history dates to Hideyoshi Toyotomi's unification of Japan and buildup of fortifications around the Osaka keep.

Several times during the year the shrine holds special carnivals when they sell SUMIYOSHI-ODORI. A mobile made of straw, paper and cloth, it is hung where the slightest breeze will set is spinning. The paper entrance to the "dance" is crudely printed with a torii which carries a banner reading Sumiyoshi Odori. The torii is flanked with two equally simple representations of pine trees — symbols of longevity in Japan. Entering the dance, one meets four straw figurines clothed with multihued tunics. They are enclosed with short red curtain. The total design is simplicity in action. The balance of the figures, curtain and entry is such that it turns easily in whatever wind is stirring.

These mobiles aren't sold in summer so one wonders why they are in mobile form? The answer most probably is that the image conjured up by the dancing figures is an invocation to the gods for beneficial intercession. They try to capture the god's attention with this "toy" reminder of their faith in the positive results of believing.

Other shrines use various but similar toys to achieve the same results. Kumade (rakes) festooned with all sort of good luck, wealth and longevity symbols are widely sold throughout Japan at shrines on Tori-no-ichi or days of the cock. They are similar in meaning to the Sumiyoshi Jinja's delicately balanced mobiles.

The flimsy construction is intentional as they are supposed to be renewed (rebought) each year to keep favor with the shrine gods. Old ones are usually brought back to the shrine to be burned at the same time one shops for a new one.

NINGYO-FUDE

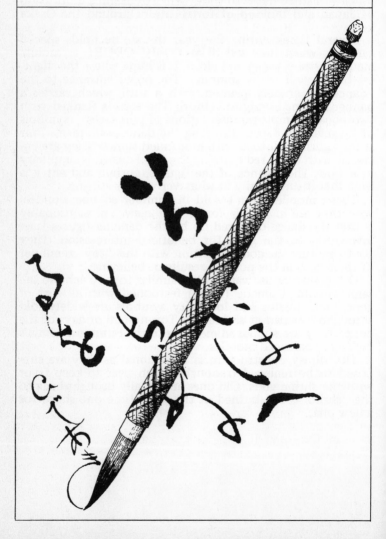

Hyogo-ken stretching from the once lovely Seto Inland Sea to the Japan Sea, is a prefecture of industrial progress and almost pristine, unspoiled nature. Some remoter villages are really isolated from much of what occurs regularly in the more populous sections of Japan. This aspect of isolation sparked creation of NINGYO-FUDE (writing brushes for calligraphy).

Fude are typically made of animal hair specially bound to form a delicate tip. Badger and rabbit are commonly used, although everything from horse and goat to some more exotic animals are also used these days. Size varies greatly. Some are thick, unwieldy brushes composed of thousands of long hairs used to create the massive calligraphy for decorating hanging scrolls and byobu (folding screens). The daintiest are used to write the miniscule characters found on such items as sutras hidden away in reliquaries. Some of these brushes have only two or three hairs (typically rat hairs) where the ink is held. Each calligraphic school style has its own preference as to the type of fude they use.

Shapes vary from a long and narrow awl-like taper to a short and fat acorn form. There are as many types as one could possibly imagine but the ningyo-fude is no doubt one of the most unusual. Basically it is just a regular brush. The villages where it was made were rather poor places that had a difficult time making ends meet every year. The idea of making a brush so it would have special appeal began long ago.

The hollow bamboo sleeve is fitted with a small daruma-style doll weighted to pop up when the brush is held in writing position. A sure and direct appeal to youthful attention, the doll only pops out when the brush is held correctly, so it isn't just play but an educational aid too! The shank is also decorated with crisscross windings of multhued sliken threads. Learning the syllabary is so difficut here in Japan that any way to lighten that task is welcomed. Ningyo-fude were an early attempt at just that and so created a bit of folk art that we can enjoy and use still in this day of "automatic" fude with cartridge ink loading.

NAGASHI-BINA

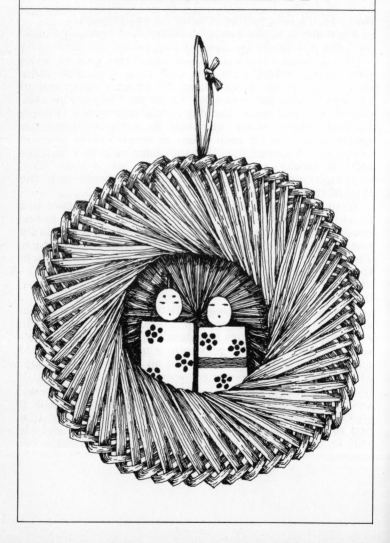

The Japan Sea coast is a dreadful place in winter when cold winds bring waves and high surf crashing into the shore. Tottori is one of the prefectures that fronts this coast as the main island of Honshu comes to its southwestern extremes. NAGASHI-BINA are thought to have originated there about the 15th C. Made of clay and paper and generally found in pairs, the paper kimono of nagashi-bina is typically red decorated with a simple white dot pattern resembling peach blossoms.

There are two types of nagashi-bina. One is a set of 10 pairs of such dolls caught in a slit bamboo holder. The other is the set illustrated, framed within a buoyant pad of straw. Both are common and usually make their appearance about Mar. 3 which is Hina Matsuri (Doll's Festival). Peach blossoms which are simply shown on nagashi-bina paper kimono symbolize marital fidelity and happiness. They also signify the womanly characteristics of softness, mild mannerisms and peace.

Tottori residents generally buy one set or the other at Hina Matsuri. Placed on the altar in their home to protect them through the coming year, last year's dolls are taken to either the seaside or a river and set afloat. As they go out of sight, they are thought to take with them bad luck and unhappines and symbolize the hope that all accidents will thus be avoided, having been discarded beforehand in the personages of these small dolls.

It should be mentioned that, formerly, it was the custom to buy TWO sets of these dolls. One to keep and one to set afloat. This has gradually given way to the more economical situation of throwing away the previous year's charm while displaying the newer one. They and a host of representative charms of similar style are all connected with Shinto worship practices. The male figure is typically phallic whilst the female is easily identified by the obi binding at her waist. They were and are directly connected with purification rituals that occupy many of the religious austerities of the Shinto cult. See colour plate on page 127.

HANA-GOZA

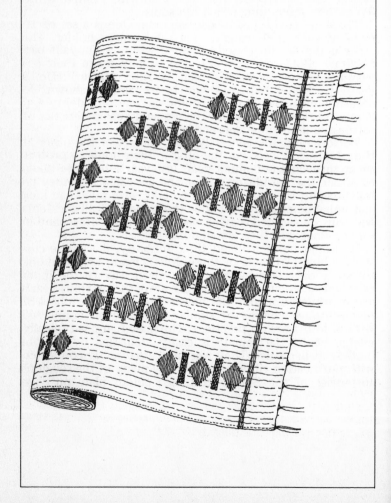

The end of summer when igusa is harvested is the most exciting time concerning this folk art. That's when you see truckloads of the thin but very flexible reeds being harvested and prepared. The grasses are bleached and softened before being dyed with a whole spectrum of colors. Then huge bundles of these brilliantly toned grasses are loaded onto trucks for carting to the weavers. That's right — grass to the weavers! No Rumplestiltskin grass into gold business though. These grasses, which flourish in the fertile soils of Okayama-ken, are used to make HANA-GOZA.

Hana translates as flower and goza is the term for matting. So popular throughout Japan, they are historically a very old item. Ancient homes had no tatami as we now have. Only the wealthiest had such permanent thick straw-filled mats. Ordinary people covered their wood or dirt floors with matting made of reeds (goza).

One of the logical extensions of producing these easily made grass-reed mats was to incorporate colored designs into their finished surfaces. By creating a host of simply loomed designs and using a wide color range of predyed igusa, hana-goza was born. They became quite popular and remain so today.

Okayama is still the center of production, mainly due the prevalence of fields of igusa that grow tall and sturdy there. Today, not only floor matting but also table place mats, coasters for those long, cool summer drinks, and a wide assortment of wallets, key cases and the like are produced. These modernized uses show some of the versatility of igusa, and the distincitively patterned designs that cover the grassy outer surfaces are a pleasure to both view and touch. Just like walking in your bare feet on tatami, feeling the smooth coolness of hana-goza in your hand is part of the appreciation this folk art imparts.

The mats themselves come in a number of sizes — from half-sized pieces almost perfect for tablecloths to several full tatami-sized units seamed together to create a summer weight and comfortable carpet. Hana-goza are available throughout Japan, although you generally can only find them stocked during the months approaching summer and of course during the height of that season.

FUSHINA-YAKI

The signal glaze tone of this folk pottery is a garish yellow that varies slightly due to composition and kiln changes. Sometimes it's so bright and unearthly that it is nauseating but more often is it a lovely corn color that contrasts well with the rich brown (ame) that usually is applied with it.

FUSHINA-YAKI has a long history centering on the small hamlet of Fushina perched on a rocky knoll beside Lake Shinji in Shimane-ken. There are three kilns within the village while only a short way off is located a spinoff kiln — Yumachi — spawned by a Fushina craftsman striking off on his own sometime ago. The Funaki family, engaged in the production of Fushina-yaki since 1764, are undoubtedly the leaders of innovation and mainstay of tradition in this small close-knit community.

The wares are often hued with the yellow and brown combination but they also produce green, white and blue glazes in considerable amounts. Several of these glazes are lead-based. Only raku potters in Japan have a similar tradition in using lead glazes. Please note there is no danger to health from these glazes because of the high temperature firing each piece undergoes. Low-fire lead-glazed wares pose the problem, but not Fushina.

Many books erroneously list these glazes as having been of recent origin and particularly having been introduced to Fushina by no less a duo than Hamada Shoji and Bernard Leach. Granted they did much to restore confidence in continuance of folk art when it was failing badly, but they merely introduced new glazing mannerisms, not the glazes themselves.

The mannerisms were/are direct borrows from English slipware which is done on greenware with contrasting glaze shades. The pressformed piece is covered with a judicious layer of thick glaze. While this glaze is still damp, a second tone is added in swaths crisscrossing the piece. By running a stylus or other instrument through the two glazes, they are partially run together and allowed to dry. When fired, these glazes become the brightly contrasting glazes by which Fushina is characterized.

Slip is applied with syringes and fude. Not only stripes but flowerlike dots and pointillist patterns are also popular. Styles made are often borrowed directly from Western designs, like the rectangular kneading bowl with its thick walls and unglazed edging.

BINGO-GASURI

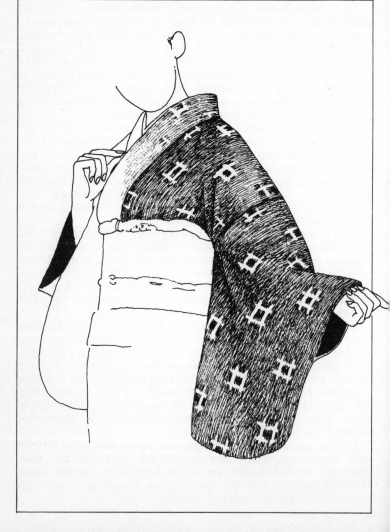

Hiroshima-ken's BINGO-GASURI is a variety of pre-dyed cotton cloth with patterns predetermined by the spacing sequences given the weft threads before weaving. Warp (or the lengthwise threads) are also dyed and expertise of the weaver brings them to perfect matches creating two-dimensional designs.

The first weaver of this type of cloth is thought to have been Kyusaburo Tomita but he could not have done so had cotton not arrived in a most unusual way.

In 1799, during the reign of the Emperor Kammu, a small boat went aground in the province of Mikawa. The young man in the boat, dressed oddly with a blue toga, was not able to communicate intelligibly. He brought with him a single-stringed instrument and a few other personal effects. Chief amongst them happened to be seed for raw cotton which was soon introduced to many provinces near the Inland Sea and in Kyushu.

The young man eventually learned enough Japanese to express himself and it was learned that he had come from India. He moved to a village which adopted the name Tenjikumura or Indian village. That rendering was eventually changed to read "celestial bamboo," although the village shrine is still dedicated to that first Indian who brought cotton to Japan.

A precursor to the importing of cotton seeds was the arrival of a group via Korea. It is now assumed that they were Tibetans. Their main craft seems to have been weaving and the Emperor Ohjin named the group leader to be in charge of nationwide weaving. His name Hata has thus come down to us via the term for a loom and through "hata-ori" which means weaver. Since the Indian arrived many generations after the weaving Tibetans, he was called the new Hata or shin-hata which corrupted into Shibata, the popular name for his namesake shrine.

What it all boils down to is that weaving was elevated to a fine craft through foreign technology and again aided by the introduction of cotton. Two factors that have a great deal to do with the eventual production of all kasuri. Today's BINGO-GASURI comes in wide spectrum of colors, although the original limitations were indigo and white with minor highlights of pale yellow and green available. One can now find this style cloth in every shade from vermillion through black.

KINGYO-CHOCHIN

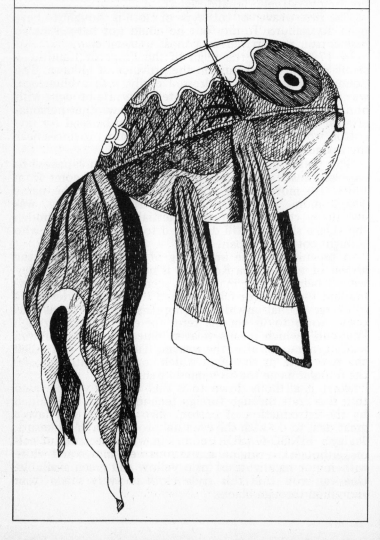

The Meiji Restoration brought economic changes to all Japanese, from those at the very pinnacles of power through the lowest levels of society. Some changes were foreseen and prepared for but most were swift and ruthless acts of policy that did much damage to the fiber of Japan's feudal system. A system that had run its course most assuredly, but how was one to know?

Yamaguchi-ken in the far southwest of Honshu, Japan's largest and most populous island, was especially hard hit by the reforms carried out in the name of Meiji and bent on revitalizing and refurbishing the land of the Sun Goddess' descendants. Among those who found themselves without jobs were many samurai. With no means of support other than their hereditary talents as fighting men, they were forced to find new livelihoods.

One of these gentlemen-warriors with a talent for creativity struck upon the idea of fashioning a simple paper lantern in the guise of a gold-fish to sell at markets and festivals. No doubt the original thought was merely a stopgap idea to prevent starvation in his family but the idea took hold and the result is that event today one can find these charming airy paper fish in shops from Iwakumi to Hofu.

Stalls selling them are still featured at festivals throughout the region and seeing hundreds of faintly lit lanterns brightly decorated with red dye and streaming tails make one imagine they have fallen into a pond teeming with luminous goldfish. KINGYO-CHOCHIN (goldfish lanterns) come in several sizes and are simply made from a rough form of bamboo staves covered with handmade paper. Drooping fins and tail are attached to the globular body and the jaunty red cleverly painted in to resemble characteristic coloration of these large and expensive pond dwellers. A small candle is used to light these lanterns and their presence in a summer garden is more than enough to safisfy every viewer.

The first maker of these airborne fishes took materials that were close at hand for his basics. Yamaguchi is known for fine handmade paper and of course bamboo is endemic to all parts of Japan. It only required an imaginative spark to bring these materials together and form a simple but pleasing work of folk art that would stand the test of time and remain to please countless generations.

HOKO-SAN

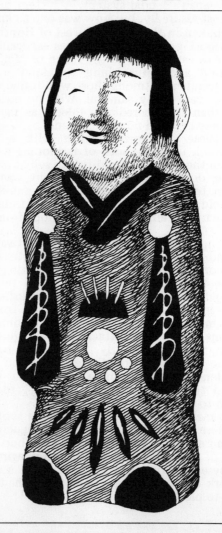

Long ago lived a small girl who was not very pretty. As homely as she was that didn't mean she didn't have a kind and loving heart. Just a child, she was also maid-servant to a very beautiful princess. Maidservants to princesses were then called Hoko, although her real name was Omaki.

Omaki's mistress took very ill with a disease that threatened to take her life and that of all who came near her. The young maid so loved her mistress that she took it upon herself to minister to her needs and help her recover. Her attention to her mistress was rewarded by the princess' recovery, but then Omaki herself became very ill with the same disease.

To protect her mistress and others from falling ill, Omaki ran way. She went to the seahore and waded out to a small island where she eventually died. Everyone was afraid to go near her but nevertheless everyone respected her for her bravery and sacrifice. To commemorate the angelic compassion of this homely little maiden, the local people began to make dolls dressed in a long-sleeved scarlet kimono much like the one Omaki wore.

Indentical figurines are popular still in Kagawa-ken — one of the gateways to Shikoku. Made by many people these days, one of the oldest happens to be an woman in her late 80s. She has spent nearly her whole life reproducing these papier-mache dolls painted with red kimono and sho-chiku-bai motif.

People still respect the ideals for which the original doll was made — to commemorate and show respect for the compassionate devotion of a small child. They also believe by purchasing such a figurine, they can transfer future illnesses from their children to the sea. Newly purchased dolls are given to children to hold and then cast into the sea with the hope transfer of all illness has been effected.

One finds similar style folk art throughout Japan but none has so endearing a tale as this story from long ago about little Omaki. HOKO-SAN is the name she goes by today, but that is merely the way of folk tales after having been told over and over so many times.

SUIREN-BACHI

Tokushima-ken is noted for the swirling whirlpools of Naruto Straits, located between Awajishima and Shikoku. In the suburbs of the port of Naruto are a number of kilns that have an unusual style of potting — NEROKURO. Two men are required to pot in this manner. One lies prone on the floor using his feet to rotate the potting wheel's base. The second is the actual potter who creates mammoth-size jars using thick ropes of clay welded into solid walls. This style of potting is called SHINNO.

The term mammoth is not an exaggeration! The largest garden jars made in this style will hold approximately 1,200 liters, while the wide, low garden basins used for cultivation of waterlilies can measure up to 1.4 meters in diameter. Such massive jars are of course not the only fare made in the Otani kilns but they are the fare upon which kiln fame firmly rests.

The kilns themselves are also gigantic. They have to be large to comfortably fit these oversize items. The huge (man-high) jars are set into firing chambers that would provide roomy, if cool, living space for most any student in this country.

SUIREN-BACHI for growing lilies are stacked inside one another in towering groups. Spacer plugs of alumina-dusted raw clay keep them from fusing together during firing. These plugs are afterward easily chipped off leaving only a ghost image of their placement on the outer lip of each basin. See colour plate on page 125.

The large jars are simple forms using only occasional splashes of colorful ash glaze, while the wide-mouthed basins have applique designs of stylized lotus pods and leaves. Finger-pinched frills and a rim of rolled clay roping add to the decorative outer design.

Visitors to these kilns will find that only one still fires their makigama. Pollution controls of the ever-spreading city environs have forced others to cease use of their nobori-gama in favor of gas-fired box kilns. Lack of customers for large pieces, as well as a lack of potters able to throw the larger sizes, has made this one of the vanishing folk arts of Japan.

TAKENOKO-GASA

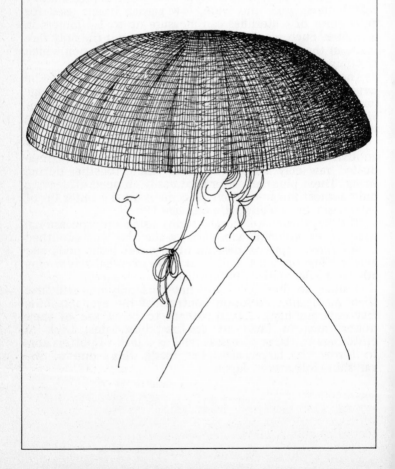

The warm currents that buffet the Pacific coastine of Shikoku have a great deal to do with the extraordinary stands of bamboo that grace Kochi-ken. Massive clusters of thick-stemmed bamboo find many uses, everything from lightweight but sturdy roofing rafters to succulent foodstuffs prepared from the young and tender shoots. If one lets these fast-growing fronds follow nature's outline, that nubbin will soon be reaching skyward with a brilliant green sectioned trunk lightly dusted with a protective layer of birthing down. The leaves that protected this shoot underground are sloughed off as it finds its way into the upper reaches of the forest. At first they, the protective sheathing sections, are quite supple and only when dry do they lose their flexibility.

Back to takenoko or the child of bamboo in Japanese. TAKENOKO-GASA is the term given a distinctive hat formerly made throughout Kochi. In many ways resembling an umbrella (kasa), the gasa of this particular hat means just that! There are two types, the one pictured and a pointed conical design which is made in essentially the same manner.

Collected fresh sheathing sections are flattened under weighted boards to make them into paperlike sheets when stiff. These sheets are laid out in overlapping spoke fashion and stitched into place. Two coils of thinly skived bamboo are spiraled into position with each binding stitch on both the outer and inner surface of the hat. These lanternlike coils strengthen the "fabric" of the hat and determine the shape it will take — shallow bowl or cone.

When the full form is completely sewn, the real inner side of the sections is on the outside of the hat, sandwiched between two bamboo spirals creating a strong but not indestructible umbrella-shaped unit. Staves of heavier bamboo are then fitted like arches within the hat to give it further durability and to allow placement of a small head-positioning cap. The inner surface is often covered with cloth behind the supporting arches, while the staves are lacquered black. The drab exterior gives no hint of the elegance underneath.

These hats were worn by all segments of society to protect them from the sun and rain. Considering their rakish styling, it is pity they haven't kept up their popularity through today when one is faced with all types of protective headgear emblazoned with inane sayings.

TOBE-YAKI

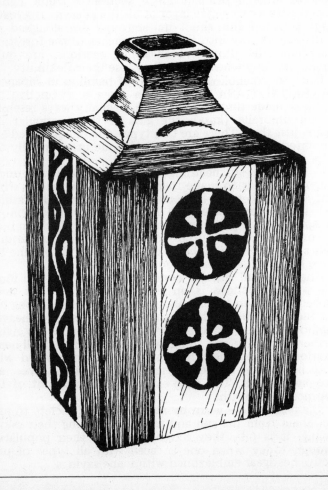

TOBE-YAKI is Ehime-ken's main mingeihin. It is widely found throughout Japan in folkcraft shops and in almost every sort of specialty shop. Why? Probably the fact that Tobe is basically porcelain, and compared with most mingei ceramics, it is very un-Japanese! The best foreign comparison may well be Scandinavian thick-walled type porcelain that have designs in quick, easy brush-strokes with cobalt and iron oxide underglazes — the same two glazes used widely for Tobe.

Tobe history hardly qualifies it as a true folk art kiln. Truth is the appelation is of fairly recent vintage. The early history of this pottery in the area around Matsuyama at the far end of Shikoku includes making Karatsu-style toki (earthenware) before turning to porcelain. Those porcelains were first hand-painted and then stamp and stencil-patterned much like those made famous in Arita. In fact, one would be hard put to differentiate between the two kilns at this date and time, although a great many Tobe area antique dealers do a thriving business in "authentic" old Tobe.

Today's Tobe "folk art" pottery is the result of a commercial experiment to revive a flagging local industry. A designer from Tokyo who had wide experience within the mingei movement was invited to Tobe to revitalize their style. He incorporated a variety of Korean-inspired designs made famous by the late Hamada Shoji and the semi-abstract free-brush designs of Tomimoto Kenkichi. A combination of the two formed the egg from which the current flock of Tobe artisans sprang.

Visually they are not unpleasing and in many cases downright attractive. On an evaluation scale, there are many more unattractive traditional ceramic styles than this one which has at least mounted the economic rostrum and made its name synonymous with folk wares.

The worst one can say about some Tobe is that it is often far too repetitive. Individuality is swamped by mass production. A design may be extraordinary but when one is faced with hundreds of identical pots, the situation changes drastically.

But if one looks carefully, there are many fine singular works available in the smaller shops. Typically they have a more select collection by only a few potters who are proud to sign their name after inking in the term — Tobe.

KI-USO

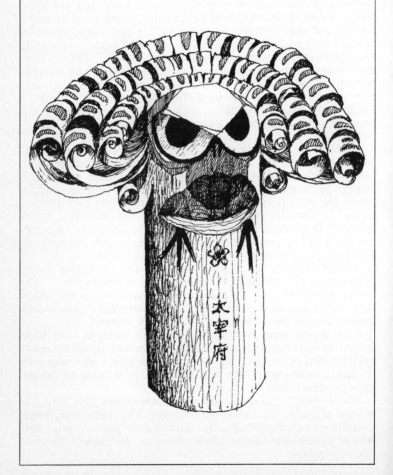

There is surely not a single school-age child in Japan who doesn't know of Sugawara Michizane (845 — 903). This gentleman of the Heian period was a renowned scholar of Chinese literature. At one time he held the most prestigious post in the court at Kyoto — the position called "Minister of the Right," but personality clashes seemed to dominate court-oriented politics of that period, and he was demoted to the post of Vice-Governor-General of Kyushu. Being sent so far from the center of government was in effect banishment. Michizane, on arriving at his new home, the residence of the Governor-General (Dazaifu), never left there. He remained in seclusion, devoting his whole energies to study, till he died in 903.

Dazaifu is the name now given the town where that residence stood and is also the name of the shrine dedicated to this illustrious and studious Heian noble. Actually called Dazaifu Tenmangu, it is the primary shrine from which thousands of smaller jinja have sprung up all over Japan — each dedicated to the memory of Michizane.

Small wooden birds sold at Dazaifu are called KI-USO (wooden bullfinch in English). Now, why this particular item has become a hot seller at Dazaifu is a bit of a mystery. The shrine is certainly best known for aiding the scholarly, and many a student has petitioned the deified Michizane for help in overcoming any or all of the educational hurdles to university graduation. The bird's name is a homonym for lie (as in white lie) and is thus sold to protect the teller when he lies. If the buyer buys a new one every year on Jan. 7, which is Uso-kai or festival day for the bullfinch, his lies will become truths.

Well, I said it was a mystery why this particular style charm had become THE item at Dazaifu, didn't I? Anyhow, that's what one does with these charming little hand-carved birds. Whittled from a single piece of wood with their tail feathers neatly skived into curlicues, red and green are painted onto the soft wooden body and the top patch is a sheet of gold foil. All in an effort to re-create the colorful characteristics of the real USO to bridge it to the USO which means bending the truth a bit!

The plum blossom crest stamped on the front of the pedestal is the symbol of the shrine (which is spelled out in kanji just below). Why a plum? See the chapter on Tenjin-sama. Dazaifu Tenmungu is located not far from Hakata in Fukuoka-ken.

ONDA & KOISHIBARA-YAKI

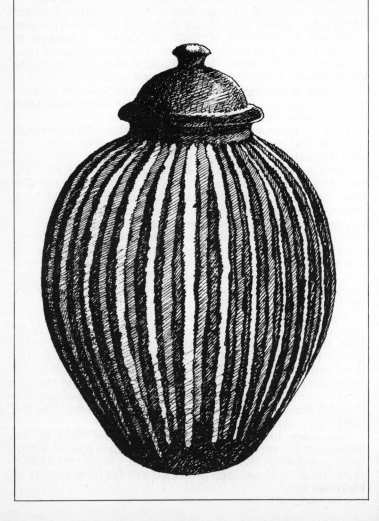

It's almost impossible to separate Onda from Koishibara, except as the national government does by placing Onda in Oita-ken and its closely related neighbor in Fukuoka-ken. Deep into the mountains, both Onda and Koishibara are mingei potteries. They share roots some three centuries back when one spawned the other but I refuse to be drawn into the fray about which came first. Chicken may taste quite unlike egg, but is it really important which occurred earliest in the scale of evolution? The same applies to chronological histories of these two interrelated kilns.

Clays are dug from the surrounding mountains. Resembling soft rock when it first comes to town, only after it has been subjected to a severe beating can it begin to resemble clay. Raw material is fed into a pit beneath a water-driven piston crusher where the pounding it receives from the falling log creates a fine powder which is made into clay slurry with water.

Potters use a peculiar potting style which is a combination of throwing and coil-building. Each pot is built up with successive coils before being turned at high speed and pressure-welded into a solid form. This type of potting is found only in a few spots — all with the common distinction of having been begun by Korean immigrants.

Glazing is what really sets these kilns off. Some works are covered with a thin veneer of slip which, when leather-hard, is partially chipped off with a vibrating kanna (knife) to create a pattern known as KASURI-MON. The idea is borrowed from similar but reverse dark slip over light clay base pieces made in China during the Sung dynasty.

HAKEME denotes the use of the wide flat HAKE or short bristle brush. Used first as a scoop to ladle in a quantity of slip, the hake allows for a grainy brushstroke finish that is much prized and extremely hard to evenly accomplish.

In NAGASHI-GUSURI, the type of glazing the illustration shows, small amounts of glaze are placed about the upper rim and allowed to flow freely toward the base when fired. By knowing how much to put at the top so it doesn't reach at the very bottom is the practitioner's secret. A secret anyone can master if they have enough time and pots to practice with. Frequently, two shades of glaze are used over a contrasting base and the end result is extremely attractive.

SHIO-TEGO

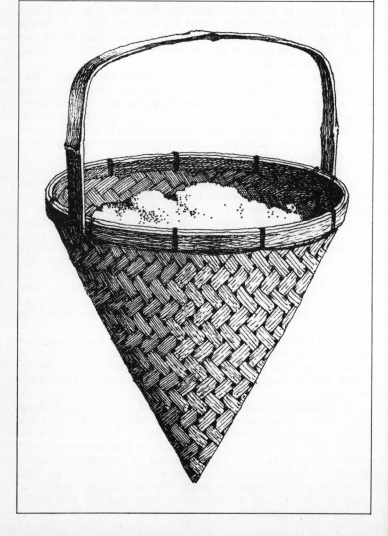

Miyazaki-ken's long, fairly straight Pacific coastline is a protected national park called Nichinan extending from Aoshima to Cape Toi — a distance of nearly 50 kilometres. Cape Toi is famous for wild horses and giant tree ferns. This prefecture is subtropical so one can easily find stands of bamboo everywhere.

This pliable plant is inexorably intertwined with the culture of the Japanese, and Miyazaki is famed for a vareity of kago (baskets) including SHIO-TEGO which means salt carry. Its conical shape, tight weave and tall handle all have a special reason.

The extra long handle is for toting the salt home without losing any as well as hanging it conveniently in the kitchen area. It will be hung so the cone tip is over a small cup.

The tight weave prevents the natural sea salt from drying too quickly. It is preferable the salt stay moist until that wetness can seep to the tip at the base and fall into the waiting cup below.

By now you see why the cone shape — to lead the draining nigari (bittern) into a cup for future use. An important future use if you like to do things right. Bittern happens to be a congealant for properly made tofu and is used when the ground beans are first boiled to jell the bean curd. Other chemicals are used now but the old-time farmer's wife had to use brine and where did one get brine but from the sea.

The charm of true mingeihin is a straightforward function that dictated simple design. The type of design that today makes us all stop and stare. A built-in beauty that defies time with its ageless styling. Shio-tego may be going the way of many "outdated" kitchenware but perhaps the renewed awareness of natural foodstuffs will bring it back from the brink of extinction.

For those wondering why Miyazaki for a salt basket, the truth is almost every prefecture that has a coast produced sea salt and similar baskets.

NAESHIROGAWA-YAKI

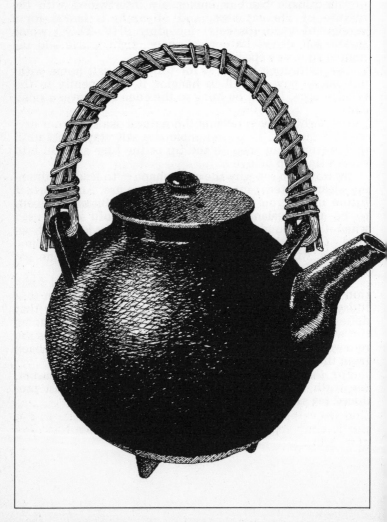

Since the Satsuma Rebellion in the early years of Meiji, about the only thing one reads concerning Kagoshima-ken is the rumblings of its famed volcano — Sakurajima. But that isn't all the prefecture is noted for. There is, of course, white Satsuma ceramics, with their intricate and multihued patterns and Sakurajima daikon: huge radishes often having diameters of more than 50 cm (that means about 1.5 meters in circumference). These are harvested early each year for pickling in either sake or miso — a special delicacy well known throughout the land.

In many ways, this mingei pottery is equally well known, although by a variety of names. People tend to call it erroneously by the title black Satsuma (kuro-Satsuma) in opposition to the shiro or white wares of Kagoshima proper. In truth there were three kilns — Chosa, Tatano and Naeshirogawa producing almost indentical wares. The first two are no longer extant, but NAESHIROGAWA has blossomed into a popular folk kiln with a continuing tradition of simple but esthetically pleasing pottery.

This kiln and others were originally started by impressed talent from neighboring Korea. The aborted invasion by Hideyoshi in 1598 returned not only the invading armies but also goodly numbers of conscripted Koreans. Potting talent was especially prized and many of the best known Kyushu kilns originated with these kidnapped Korean potters. In most cases, today's wares are only faintly reminiscent, if at all, of Korean ceramics. Not so with Naeshirogawa. The unglazed lips of sturdy bowl lids are still featured, as is a thick, functional solid black glaze. Shapes are simple, direct translations of need into object and the wide range available is amazing.

The "teapot" pictured is not that at all. It is a CHOKO or heating vessel for shochu (low quality distilled spirits made from rice and potatoes). The AKEBI handle perfectly contrasts with the smooth black finish and rotund form. Small feet are added to keep the pot from direct contact with burning coals and to allow better heat circulation beneath. Functional design from start to finish, this pot is truly representative of folk art from the Naeshirogawa kilns.

FUTAKAWA-YAKI

Kyushu is rife with kilns and many are true mingei-gama using the methods and mannerisms of times long past. FUTAKAWA is such a kiln, although various "experts" have written it off as being inactive. Futakawa in Fukuoka-ken, perhaps not the huge manufactury it once was, nevertheless continues a tradition dating back several centuries.

A distinctive style combines a pine motif with customized mountainsides. One or the other is found centered on each large platter, and both are found front and back on the large water basins (mizubachi), two wares that were the main output of Futakawa for a number of years. Their use was originally tied to the local production of wax. One thing for sure is that wax is no longer made of tallow, nor by the methods employed even 50 years ago, and so Futakawa's styling was nearly lost.

In fact, the kiln was closed for several years but was reactivated in the late 1940's by the father of the present kiln master. Sensibly, the kiln, rescued from oblivion, is making wares that include the two former best sellers but also branching into more useful-sized wares. Likewise does the kiln make new pine bough and mountain peak patterns to fit the reduced size of the pictoral area: new "traditional" designs that are right in line with a continued mingei tradition.

Each pot is coated with a thick layer of white slip over which is painted decorative patterns. Both rise from a wavy seabed that surrounds the base of each basin and sometimes edges the rim of the largest wax - kneading platters. The pine faces the wind with a jaunty arch, while the classic rocky mountain is dotted with small pines and footed in a lichen-covered base. The free hand the mingei artisan is given in putting his thoughts into physical form is evident with the perspective allowed this decorative pottery. A plate is shown on page 125.

KUJIRA-GURUMA

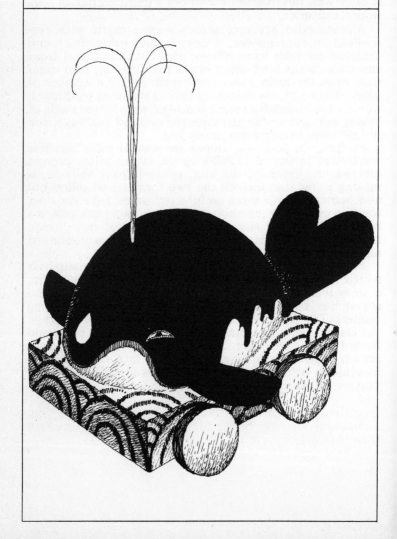

Every autumn in Nagasaki local people celebrate with assorted festivals good harvests from both land and sea. Okunchi Matsuri's main attraction is the massive float dragged through the streets of a huge, cheerful-faced whale. The mammoth of the deep is supposedly sounding and the name of the float is thus "kujira no shiofuki." A simple translation is "a whale spraying salt."

Anyone who has ever seen such a sight as sounding whales can hardly forget it. Once you know they are out there in the deep, you wait expectantly for them to break surface in the rolling seas and belch forth huge plumes of frothy seawater. The sight of one is memorable, and the sight of a herd in apparent playful unison is something to remember long after the event has ended.

Nagasaki has never been a strong whaling base,but rather people along the shores that swirl in and out of its numerous bays are great fans of these behemoths of the deep.

The great float that characterizes a sounding whale is dragged through the streets during festival time by groups of yukata-clad youths. To see this gigantic sea creature wheeled up between overhanging eaves delights young and old spectators alike as a symbol of the bounty of the sea brought home (or at least close by). Those who wish to bring one home (and most of the younger set wish to, it seems) can have a miniature replica of the street-towed float. Made of papier-mache, the bulbous body rests on a box of waves while sporting a plume of spray. The comical twinkle in the whale's eye is there because they are such happy creatures and who would want a sad-eyed symbol to liven up autumnal festivities?

This toy is but one of many objects that use the whale for a theme, but when it comes to Nagasaki, the first base for foreigners in Japan, it has to be one of the best liked and widely known folk toys of the prefecture.

A very similar whale cart in miniature is made in Kochiken on Shikoku. The maker of Nagasaki's KUJIRA-GURUMA died recently and production has stopped. Temporarily as one hopes someone will take up making these memorable toys again!

OZAKI-NINGYO

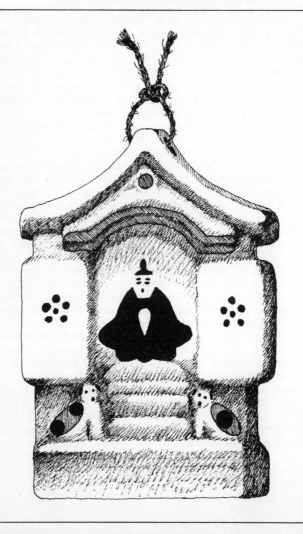

Saga-ken is a hotbed of ceramic activity, having at least eight distinct styles. It seems only natural that mingeihin from this prefecture would also be ceramic, although not on the level of the fine porcelains for which Saga is especially noted. The history of this item goes back just over 700 years to the first Mongol invasion.

The Yuan Dynasty in China was then headed by its founder — Kublai Khan. Grandson of the great and fierce Genghis Khan who had subjugated most of Asia and Europe during his own lifetime, Kublai Khan (of Xanadu fame) sent an envoy to Emperor Kameyama to gain tribute (and control) of this land. The Kamakura Bakufu was then in charge of governing and the Hojo regent, Tokimune, refused to either consider or reply to his message. He went so far as to order all subsequent envoys turned back — and some were, the worse for wear, it seems. Wisely he also ordered defensive fortifications built about the most logical point of entry for any invading forces Khan might send. They weren't long in coming, the first group arriving in 1274.

Preparations paid off and the forces of the mighty Chinese (Mongol) emperor were driven off, leaving only scattered remnants of wounded and boatless invaders. They were gathered together and kept in isolation at the village of Ozaki where supposedly, even today, there exists a house of Mongol design. No doubt, they were kept for intelligence purposes, but legend has it they were responsible for the first production of Ozaki ningyo: baked and painted clay figurines used for deity invocations. Chinese religious traditions often utilized such figurines, and the link was no doubt firmly rooted in the faith of the captured warriors.

So smitten were local inhabitants of Ozaki with the Mongol's faith that they continued making similar figurines through the intervening seven centuries. Simply moulded and sparsely decorated images with only hints of color, they are amongst the most appealing of Japan's folk toys, with links to the past that are traceable and historic.

JISHI-GAMI

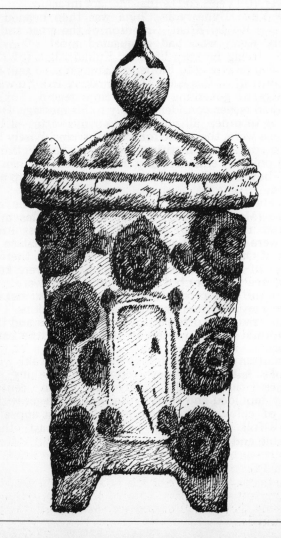

Japan's southernmost extremity is known as Okinawa or the Ryukyu Islands. Ryukyus really refers to the whole of the island chain that extends far onto the East China Sea. The largest and main island is, of course, Okinawa proper. In 1972, when the islands reverted to Japanese rule, Okinawa become the 47th prefecture.

Okinawan culture owes its unique characteristics to China and Southeast Asia. At one time not too long ago, Okinawa had its own government headed by a hereditary monarch. Most buildings and monuments dating to those times were destroyed in the fierce battle for control of this gateway to Japan during the Pacific War. Several have been painstakingly reconstructed, but many were completely obliterated and lost.

One of the more interesting borrowings from the Asian mainland is the Okinawan manner of burial. Very much like those found throughout Korea and China are the mounded stone vaults that dot the countryside. These chambers were and still are family vaults — the bigger and more elaborate ones belonging to the wealthier and higher classes.

Okinawans traditionally bury their dead. After a period of time, the bones are exhumed and placed in a special ceramic container and stored in the collective tomb. Those pottery vessels for bones of the deceased are called JISHI-GAMI, which translates to something like a "container dedicated to Buddha's enveloping love." Jishi actually refers to the doorlike decoration on the vessel, while gami is a rendering of kame (jar, pot or urn).

They come in a variety of styles, but most are in the shape of a steep gabled house with the symbolic door. The door space is also the spot where name plaques are affixed telling who's inside. These squaresided pots have removable roof lids and are heavily glazed. Some have decidedly Chinese-style architectural formats, but most have a simplified decor and basic Tsuboya-yaki coloring. The more ornate pieces are quite large and were usually for the upper classes. The average person most often used a simply thrown and unglazed pot with a lid, leaving it secreted in a rocky crevass or cliff overhang instead of a mounded tumulus.

A national law that restricts body burial is forcing the abandonment of funerary urns of this style, but for the time being they still exist and are widely used throughout the Ryukyus.

KIJI-GURUMA

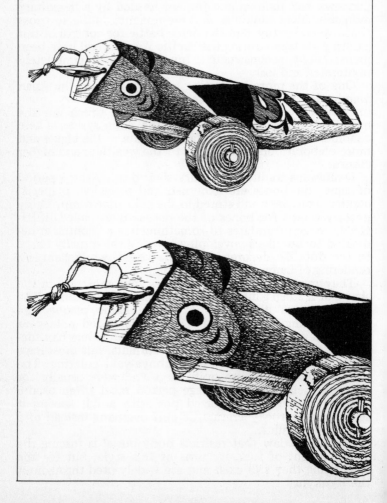

The history behind making this wheeled pheasant is poignant and interesting. One must go all the way back to the times of the Heike. This clan, forced to flee from the capital, was eventually routed in two decisive battles. One was the Ichinotani defeat in presentday Hyogo Prefecture and the last was the sea battle at Dannoura near Shimonoseki. The Gempei War left scattered remnants of the Heike seeking refuge wherever they could. In the mountains of Kyushu the village leader of Gokasho (in Kumamoto-ken) was thought to be kindly disposed toward the Heike cause and so several survivors found their way to his small community. To their dismay, they found him dead and no real refuge nor way to earn a living. Like so many others caught in similar straits, one of the families set about devising a living which was the production of KIJI-GURUMA and hagoita.

The colorful kiji (pheasant) is simply carved from a single piece of wood. Angular cuts define the tail, body and beaked head of the bird, while a pair of wheels axled to its base give it child interest in mobility. Colors used for decorating come from gardenia flowers (yellow), oat leaves (green) and isebi seeds (red). Basically the kiji-guruma is thought to be a boys' toy, while hagoita (battledore), simply fashioned and decorated, were made for girls. Both were sold at matsuri and provided a livelihood for displaced Heike supporters in their new homes.

Decoration of the kiji-guruma includes two unusual points. One is the character "dai" on the back of the bird's head. This stands for the Otsuka family who first made these toys. Their idea seems to have been ripped off in the long distant past, but by way of propitiation, the simple kanji for "large" still continues. The other notable design mark is a large red tsubaki (camellia) just above the tail feather striping. This is a slightly disguised effort to show sympathy for the defeated Heike clan whose banner was a bright red.

All in all, the "pheasant car" of Kumamoto-ken is surely one of the more interesting and historically true folk art toys of Japan.

AKA-BEKO

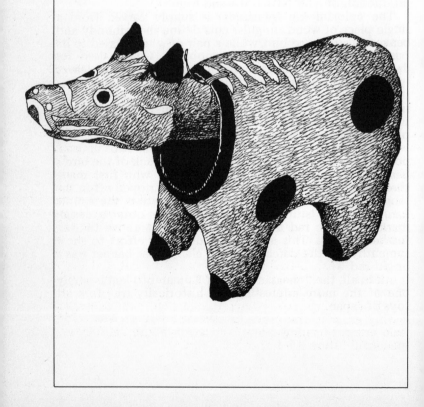

A former province in Tohoku was called Aizu. The same general area is now Fukushima-ken, where one often comes across the term Aizu in conjunction with other place-names such as Aizu-Wakamatsu, a major city famed for both lacquerware and ceramics.

Another Aizu town is Aizu-Yanazu, where some 350 years ago townspeople constructed a large temple, Kyokyuzo-do. The making of this edifice dedicated to Buddha required heavy loads of lumber and materials to be transported some distance. Of the oxen used for that purpose, one was a large reddish cow. This cow faithfully performed her work duties but when the building was completed, refused to leave the site. Stationing herself outside the gate to the temple, she become a regular fixture. As much as the temple drew attention, so did this red cow which appeared so devoted to the Lord Buddha.

It wasn't long before someone highly placed heard of the cow and came to see for himself. Shortly thereafter, this same member of the ruling clan fashioned a small effigy of the devout cow as a child's toy. Made of lacquered papier-mache, the free-swinging head bobs easily with any movement and delights children of all ages.

It seems that about that era, a great plague of smallpox swept the country and threatened the lives of many people. The people in turn appealed to Buddha's saving grace for deliverance. It was noticed that children who had this small red cow toy were not afficted with the dread disease and the superstitious local populace began to make similar toys as amulets against illness. The devout steadfastness of the original cow and her devotion to both duty and Buddha no doubt kept the omamori in good stead with the people, while the fame of the toy and its preventative powers spread. It is still primarily a toy, but with a double purpose — to amuse and protect, which makes it a winner on all levels of belief.

AKA-BEKO literally translates as red calf. It and all the hundreds of thousands that have been made over the past three and a half centuries are all children (calves) to the original reddish cow which worshipped Buddha and His saving grace in the only way she knew how. A touching tale brings this mingei-hin from the past into the future. A healthful future it is hoped!

HARIKO-NO-TORA

One of Shimane-ken's famed toys is their HARIKO-NO-TORA.

Although Japan has never had indigenous tigers, they, along with so much, were imported from China. The Oriental zodiac, which uses animal symbols for its 12-year cycle, gives the tiger the task of symbolizing the third year. This division of time by years goes several steps further as there are tiger days (one in every 12) and the tiger "hour" occurs between 3 and 5 a.m. daily. It used to be strictly observed that certain things were not done on inauspicious days and tiger days were then especially important to avoid.

In art it has always been a symbol of power or faith and was often used as the theme for fusuma paintings hung in magisterial quarters where the feeling of judicial awe and terror were required. Gamblers also favored the tiger, respecting the great cat as a symbol of bravery.

Apparently, since they have no real tigers, the Japanese fancy the domestic cat as a sort of tiger and therefore often call them tegai-no-tora or hand-fed tigers.

Whatever the case, the tiger is well established in Japan and this toy is one of many similar tigers found throughout Japan. Make of papier-mache, it has a bobbing head like the aka-beko.

The fact it is made near Izumo also helps spread its popularity, as Izumo Taisha is one of the oldest shrines in Japan. The Oyashiro, or Great Shrine of Izumo Province (present-day Shimane-ken), is dedicated to Okuni-nushi-no-Mikoto, who is thought to have lived in a grand palace there. This Shinto deity is credited with having introduced medicine, sericulture and agriculture to Japan. The current main shrine building (a national treasure) was rebuilt in 1744 and is patterned after the oldest style of architecture in Japan, predating that even of the regularly renovated Ise Grand Shrine complex.

Being the "birthplace" of Japan, so to speak, Izuno naturally has a great many visitors and most go away with a tiger or two as combination amulets and toys.

Even though there are many aspects of tiger "worship" in Japan, there are many, many warning proverbs centering on that animal too! Pushing a tiger out front gate will only bring a wolf to your back door (i.e., out of the frying pan into the fire), and feeding a tiger only brings trouble (i.e., warming a viper to your bosom) are two that come easily to mind.

HATSUTATSU-NEKO

Sumiyoshi Taisha, the grand shrine of Osaka, is well-known for an assortment of unique tsuchi-ningyo. This particular version of the more widely seen maneki-neko or beckoning cat originated in Osaka as a Kansai alternative to the Edo version.

The name, HATSUTATSU-NEKO, refers to the idea of buying one of these fashionably garbed cat (neko) statuettes on the first (hatsu) dragon (tatsu) day each month. One should collect them monthly till a set of 48 (four years worth!) have been gathered. You would then has shijuhatatsu which literally means 48 dragons. A homophonic pun on this term gives a far different reading, and the one that has the most meaning especially to the merchants who regularly purchase these cats. The shiju can be read as "always" while hatatsu means "prosperous". A great merchant-oriented motto and one most fitting for the prime merchant city of Japan, Osaka.

Each of these cats is clothed in some sort of traditional wear, either a stiff but courtly kimono with sharp, flaring shoulder pads (you've seen them in Samurai movies if you think hard enough) or the more common variety clothed in a montsuki-haori (family crested short jacket worn over a kimono). They likewise come in both left- and right-handed varieties, for another unique reason. Left paw extended is thought to beckon customers and the right paw up is thought to attract cash, so to be on the safe side you should buy a pair, one left-pawed and one right-pawed. In fact they are today often sold as pairs instead of separately!

They are the prime engi for Osaka business today but their initial introduction dates back to the Edo era shortly after the "beckoning cat tea house" episode occurred in Edo (present-day Tokyo). The idea of collecting 48 over the space of four years sounds just like a smart sales ploy that one would imagine was the brainchild of a true Osakan character. It took hold whatever the reason it began and its popularity within the "floating world" helped it bridge the years to be with us today as you can see on page 114.

TAIGURUMA

A roughly shaped fish with wheels is one of Kyushu's most famous toys. TAIGURUMA or sea bream cart, are sold at Kagoshima-jinja in the outskirts of Kokubun. The legend behind this fish toy is recounted in the ancient chronicles of Japan — the Kojiki. Two gods who appear in this story as brothers were deities of the seas and of the mountains respectively. Tiring of their regular routines, they one day decided to trade places. The sea god gave his brother his fishing pole while he took a stroll in the mountains. The brother caught but one fish and that one escaped with both hook and line. On returning home at the end of the day, the sea god was perturbed to learn that his brother had lost his best hook and ordered him to retrieve it.

The mountain god again went off to the shore and jumped into the ocean where he had fished earlier that day. Down and down he swam until he came to the Palace of the Sea Dragon where he found the lost hook still caught in the mouth of a sea bream. The tale goes on to relate how this tai (sea bream) was in reality the daughter of the Sea Dragon who persuaded the mountain god to stay on and take her to wife. He did and lived there happily for some time but eventually yearned to go back to the land and to see his brother again. His wife accompanied him on this return but upon bearing a sea creature as their first child, she dove back into the sea and returned to her father's ocean palace.

The season when the mountain god returned with his fish-wife was springtime when the fuji (wisteria) were in full bloom and so to this day, the special item sold at the Fuji-matsuri of the Kagoshima shrine is the taiguruma. It is thought their red colour helps protect children against smallpox and are purchased by parents to protect their children. This engi doubled as a toy of course and were given mainly to boys, the girls having their own special item in Kokubun kesho-bako. These amulet-toys in bright red and yellow carry the stamped name of Kagoshima Jinja clearly on their sides as can be seen in the colour photo on page 115.

USHIWAKA/BENKEI

USHIWAKA/BENKEI, an abbreviated name for this unusually simple karakuri (mechanized) toy from Aichi-ken's capital city, Nagoya, takes its title from the two protagonists emulated. They once existed in real life and are perhaps the most famous duo of heroes in the Japanese store of such memorable characters. Benkei, the larger loutish figure, was supposedly just that. A huge brute of a fellow who did what he liked whenever and to whomever he cared. The tale of his first meeting with the young Ushiwaka (Minamoto Yoshitsune's boyhood name) came when Benkei was guarding a major bridge in Kyoto. Having made a vow to fight and collect the swords of 1000 warriors, he had defeated 999 already when Ushiwaka happened along. The Western counterpart to this tale of course is the story legend of Little John and Robin Hood but let's stick to Kyoto here.

Ushiwaka, whose father had been killed and himself effectively banished by being forced to enter a remote monastery, had spent his time in the mountains quite effectively for such a young man. He persuaded a tengu master swordsman to teach him so he could eventually avenge his family name. Tengu are known to be the best of the best and Ushikawa became better than his teacher through his pure thought and determination. In fact he had just recently fled the temple monastery where he had been sent and was searching for his older brother, Yoritomo, when he met with Benkei's challenge.

It didn't take too long and Benkei was humbled, cheated in essence from fulfilling his vow of 1000 swords. but that became less important than his new situation as guardian and companion for Ushiwaka. They travelled out of the capital to find his brother, so together they could avenge the wrongful death of their father.

There are numerous tales about the situations these two got embroiled in, tales that make good reading and were the basis for many a Kabuki play. The two mechanized dolls shown in colour on page 115 imitate a festival cart used in the Nagoya Matsuri since the Edo era. There are nine carts in Nagoya's festival at Toshogu every April 16 and 17.

OBAKE-NO-KINTA

A smile will come to the face of the most hardened character if this doll head is activated in front of them. Its rolling eyes and stuck out tongue will surely evoke that smile if the general appearance of the OBAKE-NO-KINTA head didn't do so alone. Painted a deep red and capped with a special sort of headgear that soldiers of old wore, this string-activated puppet head was patterned after a real-life character. It seems that during the construction of Kumamoto Castle by Kato Kiyomasa in the mid-Edo era, he had in his employ a footsoldier by name of Kinta, a foolish sort given to clowning away the idle hours. One should note that the Edo era is better known as the time of the Tokugawa Shogunate, a span of relative prosperity throughout the nation as well as unified peace through all the provinces.

So well known for clowning about was this Kinta that his rather memorable face was later recreated into this doll's head toy. It likewise goes by the name MEKURI-DASHI-NINGYO, or the bulging-eyed doll. The "normal" face one sees changes to the stuckout tongue and rolling eyes when a pulled string activates a bamboo spring inside the red lacquered papier-mache head. It is thus classified as a karakuri or mechanized toy. There are a number of such simple mechanical toys but this Kumamoto-ken puppet head is that region's most famous.

An essay written about the turn of this century attributes the red face to the doll's habitual "drunkeness" but that just adds another twist to the story behind its origins. One look at this Kinta character as he has come down through the ages and you know he didn't depend on excess imbibing to be the clown he's credited with being.

It's written all over his face in either of its humorous positions that he was a natural comic who enjoyed being the butt of his own droll looks to the merriment of his fellow soliders and the amusement of the many artisans working on the castle construction. How the fedual Lord of the region, Kato, felt about his soldiering clown isn't passed down to us but then we have Kinta whose two undeniably funny faces are shown in colour on page 116.

HANA-TEBAKO

Heike survivors are credited with the first production of these charming camellia patterned boxes but their disastrous defeat in Kyushu is at the root of that situation. The Taira army fled in all directions after their resounding sea battle defeat. Some headed to the present site of Hitoyoshi in Kumamoto-ken where they believed the Yase clan were sympathetic to their cause. Unfortunately, the Yase had backed the wrong party in the war just ended and they too had been dispossesed. The fleeing Taira had scattered throughout Kyushu and now had to make a living for themselves and their families.

Those coming to Hitoyoshi keenly felt the lack of the many beautiful items they were accustomed to using when they had held sway in Kyoto and at the Imperial Court. And to assuage that change of status they began to create a rusticated version of a small treasure box such as they had used in the not-too-distant past. Split cedar shakes were cut to size and covered with a layering of handmade paper (washi). Atop this strong base were painted simple camellia patterns focusing primarily on the deep red of the full blooms. Red was the flag and banner colour for the now defeated Heike (Taira) army and in this none-too-subtle way they continued to espouse a lost cause.

These boxes are often called by several other names such as ICHI-BAKO, sold primarily at markets (ichi in Japanese), and KAORI-BAKO, which roughly translates as fragrant box, no doubt taking that sweet-smelling cue from its being made of fresh and fragrant cedar shakes. Painted with natural colours until quite recently, the yellow came from gardenia seeds, young wheat supplied the green tones, rice paste the white background and isebi seeds the vibrant red.

They are popular in all their sizes as gifts for a young lady, and are purchased especially at Ebisu-Ichi, a February market day for the God Ebisu who is best known as the deity of fishermen and tradesman. But regardless we have these lovely treasure boxes seen in colour on page 116 to remember the Heike by after many centuries have come and gone.

MATSUTAKE-OKAME

Phallic images abound throughout Japan. Many are rudely carved lingam worshipped as part of the naturalist Shinto religion. All of course are directly connected with fertility and the wish for healthy children, male preferably. They are so widely found that a book in English on this topic came out several years ago explaining some of the more esoteric themes behind this brand of erotic cultism.

There's no trouble placing Shiga-ken's MATSUTAKE-OKAME within the realm of fertility symbols, although the chubby supporter seems more akin to extra-curricular activities than just plain procreation. These clay press-moulded dolls are actually called Obata tsuchi-ningyo from their place of origin, Obata, a junction city located on the Nakasendo. This was one of the major highways established and maintained during the Edo era to connect outlying districts with the seat of political power.

The first dolls were presumably made by a courier whose work took him regularly over the Nakasendo artery. Despite the basically peaceful times, such work was hazardous with highwaymen waiting to ensnare the unwary. Hosoi Yasubei, the courier, tired of being in that line of work wanted something he could do at home, a place he seldom was when duty called. He settled on the making of Fushimi-style clay dolls and went to that Kyoto suburb to learn the process. He returned to Obata and established a cottage industry that his family continues nine generations later.

A pre-war mingei specialist disputes this family history in so far as it wasn't the courier Hosoi who began making such dolls but rather his great-grandson, GENSUKE, who started their production about the end of the Edo era in the 1860's. In either case, whoever is correct, these particular dolls have been around in many guises for at least a century. Maybe they weren't the Obata variety but the popularity of the original Fushimi-ningyo spread throughout Japan rather quickly and spawned numerous new types. A full colour photo is shown on page 117.

EDO-ANESAMA

Hina Matsuri occurs every March 3 and you can then easily see many fabulous displays of dolls to symbolize the festivities. It's sometimes called "Girl's Day" because of its association with dolls no doubt but also probably because the boys have their own holiday festival on May 5 every year. But one should know that not everything about the way Hina Matsuri is celebrated now has to do with the origins of the festival.

To begin with, the term itself is a corrupt form of the proper word which read HIINA. That extra "i" does make a difference! And to add injury to insult, not only has the reading been changed but also the meaning. The old hiina-matsuri was a celebration of one's ancestors in the doll forms of a man and woman with HIINA written in hiragana. Today's hina uses a character borrowed from the term hinagata meaning "model." The reference is to the sample or model dolls used.

The dolls themselves have undergone drastic changes over the centuries since this matsuri first became widely practiced and popularized. Folded paper dolls similar to the EDO-ANESAMA shown on the following page were probably the original style dolls used in this festival. But they have since become lavish affairs that can run thousands of dollars. One can't miss seeing sets prominently displayed throughout Japan during March — some heirlooms and some contemporary but all evoking the splendor of an era past.

Edo Anesama, on the other hand, are still easily fashioned from two types of coloured papers — chiyogami (patterned papers) and irogami, with solid shades. Folded to resemble layers of kimono, each doll's waist is cinched with a contrasting obi. Their hairstyles vary but are made to resemble popular styles set atop a twist of white paper to form a head. Graceful and willowy, these lightweight ladies are favorites with the children who take delight in making their own from the many varieties of patterned papers.

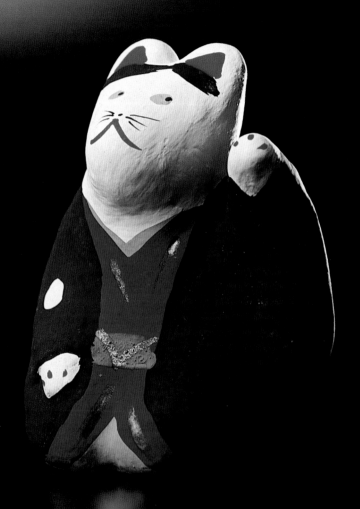

49 HATSUTATSU-NEKO

50 TAIGURUMA

51 USHIWAKA/BENKEI

52 OBAKE-NO-KINTA

53 HANA-TEBAKO

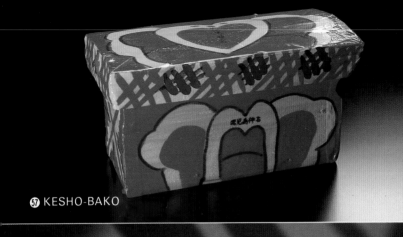

57 KESHO-BAKO

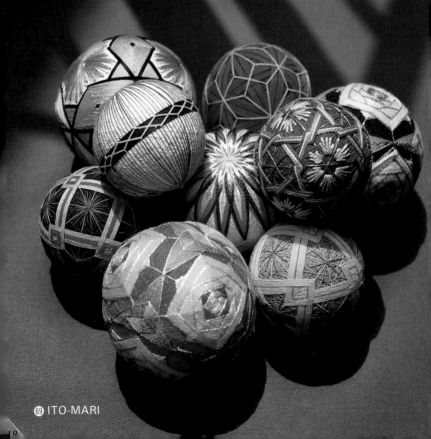

69 ITO-MARI

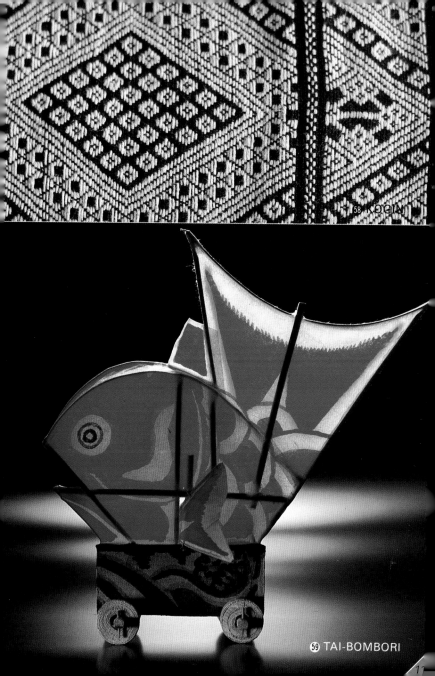

58 KOGIN

59 TAI-BOMBORI

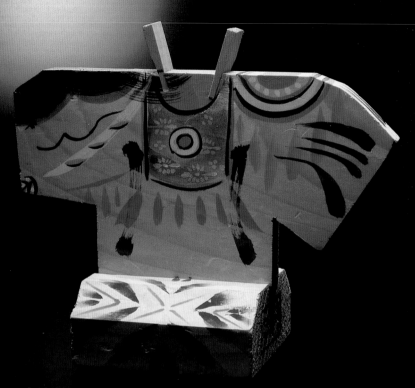

60 MAYUMI-UMA

61 YUKI-GUTSU

⑩ KATAEZOME

㉔ KAMI-GUNKAN

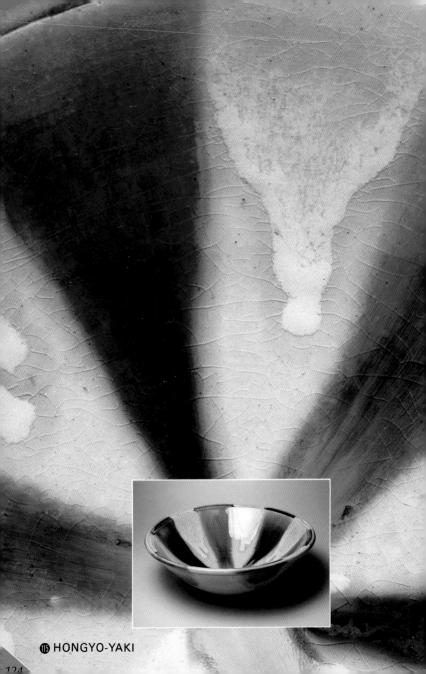

⑮ HONGYO-YAKI

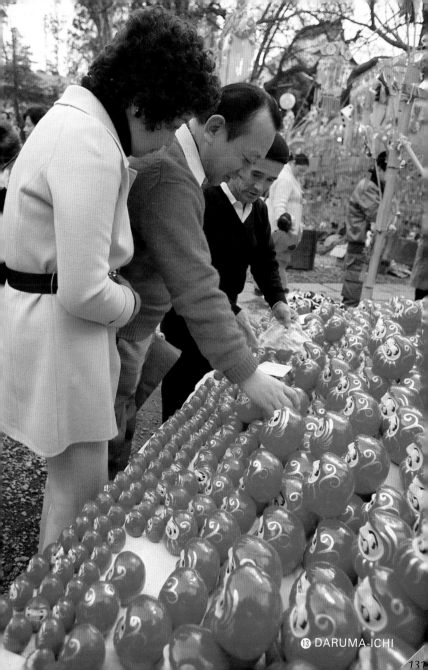

⓭ DARUMA-ICHI

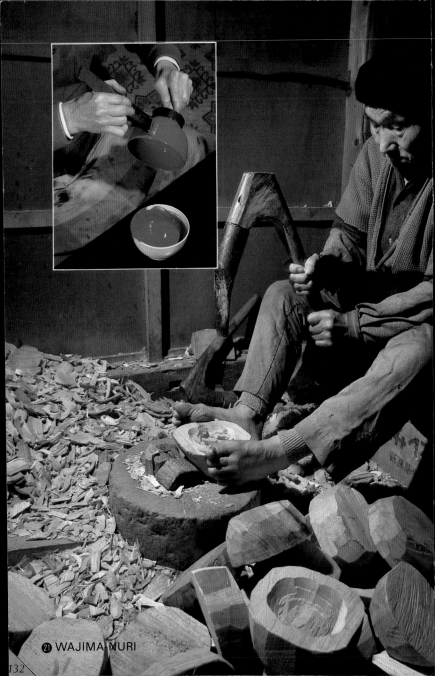

㉑ WAJIMA-NURI

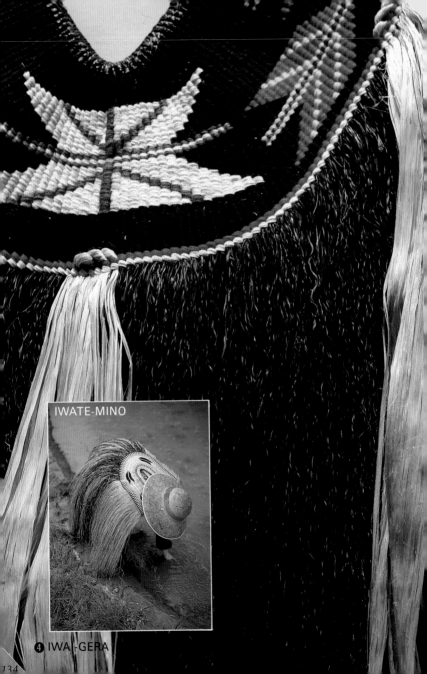

IWATE-MINO

❹ IWAI-GERA

134

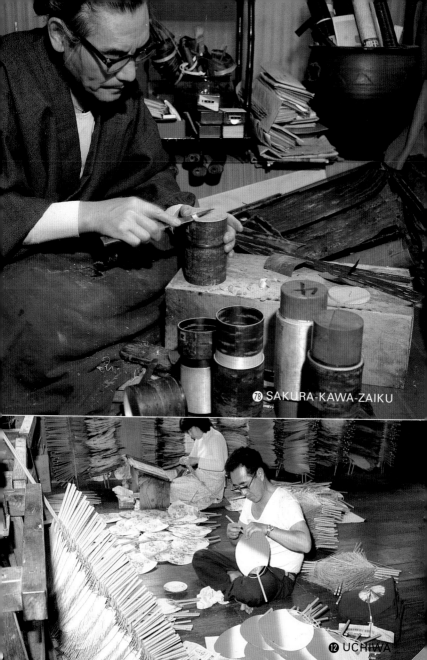

78 SAKURA-KAWA-ZAIKU

12 UCHIWA

135

KUBI-NINGYO

K UBI-NINGYO are no longer as common or popular as they once were, but several locations still produce modern versions of these centuries old playthings. Those made in Shizuoka-ken are engimono meaning they are meant to auger good luck (and in this case good health). The classical Chinese zodiac, represented by 12 animals, is the basis for Shizuoka kubi—ningyo. Both male and female are produced in all 12 varieties which consist of pinched clay heads atop thin bamboo sticks.

Colorfully painted, they are presented to tutelary shrines to protect children against intestinal worms and nightime crying and coughing. Of course, the piece given the local shrine corresponds to the zodiac figure of the child in question. Stuck into a bound plug of straw, they are humorous guardians for many a remote shrine throughout the countryside.

Normal kubi-ningyo which are made in Sado originated in what is now Tokyo but was then called Edo. The first maker of these comic doll heads was a man by the name of Noromatsu.

A comic play style grew up around these "faces" deriving their name from that of their originator-handler. The play style eventually came to isolated Sadogashima, off the Niigata coast, where any entertainment was most welcome. The enthusiasm of the islanders for these small but drolly comic puppet faces turned into production of similar pieces. Time would have it that the puppets died out in their birthplace but continue through today in remote Sado.

A third locale that produces kubi-ningyo is Tokushima-ken in Shikoku. These puppet heads are made for an unusual form of bunraku peculiar to the region. Handled from beneath and behind, the puppet heads top off elaborate costumes. They too are made of clay but in addition to finely detailed painting, they have "hair" made of plant fiber.

KESHO-BAKO

KESHO-BAKO simply translates to cosmetics box. These unusual little lidded boxes are the feminine counterparts to the preceding Taiguruma (wheeled sea bream carts) of Kagoshima Shrine. They are both Kokubun toys connected with the varied male and female dieties worshipped at this well-known Shinto shrine.

Kesho-bako are thought to have been patterned after a cosmetic box brought from the Palace of the Sea Dragon by his daughter Princess Toyotama as part of her dowry. It too is brightly hued with a leafy scroll design executed in a very naive manner. The more interesting aspect of these small enclosures is their peculiar construction — they are made of roughly split wooden shakes over which has been painted a gaudy pattern in brilliant vermillion, green and yellow. No nails or metal hardware are used in the making of this box fit for the dressing table of a sea princess. The "nails" used to hold the side boards in place are made of bamboo but the real support of the box as a whole are the strips of handmade paper (washi) used to seal each edge before it was completely painted over with its unique design and shrine stamps.

It might do to point out here that the Eastern sense of feminine beauty is quite apart from its Western counterpart. It used to be that a matt white pancake base was applied entirely to the face and neck and on this base were added minimal definitions of lips and eyebrows. Only in Kabuki and some of the stylized courtly dances can one see this extreme of cosmetic beauty today but with that in mind, you can more easily understand why any young lady might wish to have a "princess' cosmetic box" of her very own.

Other Kokubun toys doubling as engi that one finds in Kagoshima are dove-shaped clay whistles; hagoita (battledore) with both faces patterned — one side with a crane, the symbol of longevity and the reverse side showing a torii or gate entrance to a shrine; and a drum on a stick which when twirled is struck by two string-held beads. This toy drum face is likewise decorated with a torii design. A colour photo of a kesho-bako appears on page 118.

KOGIN

C otton cloth is a fairly recent introduction to Japanese culture. Prior to its widespread popularity and inexpensive availability, silk and linen (hemp) were used. Of course silk was the more expensive of the two thus mostly used by upper classes while the peasants had to make do with the rough texture of hempen material. Anyone who's ever worn a summer shirt or dress of linen knows how cool its loose weave can be. But imagine that you live in snow country where all you had to wear might be several layers of such loosely woven material.Perfect for summer but rather inadequate in winter.

Aomori was a feudal fief. Ruling clan leaders felt bringing in expensive cotton cloth was an extravagance their districts' balance of trade needn't be burdened with so they forbade its sale. Cotton yarns were allowed in and the industrious and commonsensical peasantry soon evolved KOGIN — a variety of embroidery that uses the loose warp and weft of linen cloth which was locally produced.

Kogin uses undyed white cotton yarn to fill in the blanks so-to-speak, thus making the airy cloth thicker and ultimately warmer. Truly born of necessity, there are a dozen or so basic designs that every girl in Aomori used to learn. By the time she was ready for marriage, she had usually created a special trousseau for herself that amply demonstrated her special kogin talents.

Patterns were and are used in tanden, sometimes as many as a half dozen different designs appearing on a single kimono. Realizing that doing a complete kimono would both be unnecessary and costly, most kogin was embroidered vest-style about the upper portion of wearables. Different areas favored certain pattern combinations which identified the wearer's home.

Kogin nearly disappeared with the advent of cheap and plentiful cotton yard goods after the Meiji Restoration. But under the guidance of Yanagi Soetsu, kogin was revived in the 1930's. Today a research centre at Hirosaki continues to aid its development. The only major difference today is that most kogin is done on wool instead of linen. A closeup photo appears on page 119.

TAI-BOMBORI

E CHIGO NO TAI-BOMBORI is the actual full name of this wheeled lantern from the Japan Sea coast of Niigata-ken. A light bamboo frame over which is stretched taut washi (Japanese handmade paper), this brightly tinted fish jumps from a cart of waves when viewed properly lit with a small candle at its center. The early Meiji era was when these fish cart lanterns first gained popularity and one could often see children playing with them on summer evenings. They are locally called either Tai-chochin, Taiguruma or Tai-toro.

Since it is a wheeled toy the natural inclination of any child would be to wheel it about out-of-doors and in the pre-war era, almost any summer night you could find these lantern carts being pulled along the roadways by local children. Of course there were few cars in those days and the streets and roads were really extensions of one's playground arena. Today, the economic miracle of Japan has produced streets that are no longer safe at any hour for the unwary and one seldom sees such flickering forms even in the village of Murakami on the Niigata coast where they continue to be made. Why Murakami? It is adjacent to an area of the Japan Sea famed for tai fishing so what better thing to celebrate than the fish that supports so many in the area. Another reason for why the sea bream or tai is often found on folk art has to do with its word association with the term for congraulations: OMEDETAI and the fact that this same fish is served on especially felicitous occaisions.

Each July 7th, when all Japan celebrates Tanabata Festival, a large float in the shape of a tai is dragged through the streets. The fish is connected only with auspicious happenings and the yearly meeting of the Princess Weaver star and her lover, the Herdsman star (Veda and Altair) is surely such an occaision.

These small lantern carts, TAI-BOMBORI, emulate the larger float even down to the tail piece being constructed so it will wiggle realistically when the cart rolls along. A full-colour photograph of the tai-bombori is found on page 119.

MAYUMI-UMA

This primitive looking horse was first fashioned some 600 years ago of a different type wood than the present sugi (cedar) items. Discontinued from production during the early Meiji era, priests serving at Muramatsuyama Kokuzo-do began to make them hoping to continue a special tradition historically connected to their temple.

The name mayumi is disputed as to meaning. Some say it was the name of a mountain village where cedar shakes used for making such horse effigies came from while others believe it to be the name of a village famed for horses in days of old. Either will do as no records exist to prove the accuracy of either argument.

Back to their connection with the Kokuzo-do at Muramatsuyama. This temples' origins date to 807 AD when the Buddhist saint and priest Kobo Daishi was alerted by fishermen of a strange shining phenomenon in the ocean. They were quite frightened so the priest went off to investigate the cause. He found a huge log, that was somehow phosphorescent, afloat just offshore and managed to bring it to land. He then turned his carving knife to it and produced a statue of the Lord Buddha (the Kokuzo Bosatsu). There are three such similar famous statues in Japan; one at Ise, another in Aizu and the aforementioned.

When children reach the age of 13, they could receive the full blessing of Buddha. To commemorate such an auspicious date, the 13th day of each month was slated as a market or enichi day at the temple compound. MAYUMI-UMA, in essence a three-dimensional form of ema (voitive horse picture), came to be sold at these monthly markets to bring safety to the houseowner as well as prosperity to his business. And they doubled as toys for the children which graced every household.

There is one more special date associated with this particular engi — the SHUSEIKAI held each January 15th. A special prayer meeting where pilgrims from all over came to the Kokuzo-do. Each participant was given a Mayumi-uma as a memonto to return home with. A colour plate of this folk art is on page 120.

YUKI-GUTSU

Wherever snow country extends one can find a variety of YUKI-GUTSU fashioned from locally available materials. Some prefectures make theirs of rice straw while others use the stronger cattail rushes. Styles too vary widely with some simply and crudely woven with no thought to special decoration while others are equisitely fashioned with extreme care given not only their outer form and vision but also special attention to their inner construction too. Yamagata-ken yuki-gutsu fall into this category with their split cattail creations.

Handle a pair of these boots and you'll see why they are deemed special. The cattails used are soft and pliant but fairly waterproof to snow in general. They don't function too well in slush or on hard surfaces (they aren't city-wear) but if you live in snow country that isn't a problem. Uppers have tightly woven toe fronts of finely splits rushes and backs of thicker rushes bound into dense walls. The bottoms are initially rush ends woven into a thick pad. A secondary pad is then stitched in place and this is the actual surface one walks upon. It isn't surprising to find it made of the tough but pliant skins of young bamboo shoots (takenoko-no-kawa) as were used in Nikko-geta and to waterproof takenoko-gasa. Putting the wearer one step more removed from the cold and damp is yet another inner sole pad of straw or rush. These are easily replaced or removed to be dried separately. Some stiching in hemp cording is used and often this is dyed a contrasting shade as is shown in the pair of yuki-gutsu on page 120.

Upper edges of these low boots are often trimmed with remnant cotton cloth. It used to be that red was used for women and white or aizome for men. A tight weave makes them waterproof and longer lasting. Though they are hardly used any longer, even in the most isolated hamlets of snowy Tohoku, one hopes that some of the children and grandchildren of these last yuki-gutsu artisans will pay attention to the process and keep one more link with the past alive if only for viewing purposes. They are truly works of art without ever considering their birth from necessity.

SHISHIGASHIRA

Artisans responsible for construction of the grandilo-uent Nikko Toshogu mausoleum shrine complex originated these special lion-faced masks. After completing their work on the shrine where the first Tokugawa Shoguns are honored, they settled in a nearby community called Konosu. Woodworking artisans for the main, their livelihood spawned this special form of neri-mono or "kneaded object". Made of wood shavings and sawdust mixed with rice paste at first, more recent ones utilize wheat and rice chaff as well as a better bonding paste to form the lightweight jawed lions head.

Their 190 year history associates them with festivals as one can surely guess merely by looking at them. Although they are masks, they are not worn over the face as would be expected but rather are carried high in front of the manipulator who snaps the jaw with one hand while balancing and clutching the head with his other hand. A cape of cloth similar in pattern to the small section attached to the mask covered the person underneathe so all viewers saw were the fearsome countenance of these snarling and snapping lions dancing to the accompaniement of hand drums and flutes.

One can still see such festive happenings throughout the islands at various times of the year. Many locales use their own native made SHISHIGASHIRA which will undoubtedly be quite similar to the choice piece from Saitama-ken shown on page 121. The red hue of these masks and other similarly tinted items has given then the collective generic term aka-mono or red things. Red is traditionally thought to be especially protective against smallpox, an idea borrowed from China it seems. Chinese legend holds that since the pestilent God of smallpox prefers red, he will move out of the sick to lodge in anything of that hue.

It should be noted that the masks actually used in festivals are entitled shishi-mai and are slightly larger than shishigashira. A smaller version also exists in the yumi-jishi which are minature masks controlled by a bent bamboo spring to make them snap and snarl convincingly.

BINGATA

Ryukyuan culture centered on the island of Okinawa, now Japan's southernmost prefecture, in a chain of islands called the Ryukyus. Their relative closeness to the cultures of China and Korea, not to mention their sea-going trade with South-East Asia in general, left its mark in the unique styling of its many indigenous crafts. Modern scholars even feel there was a definite and direct Middle Eastern influence no doubt due far-ranging ships that encountered those distant shores and regularly plied the sea to return again and again in the centuries past.

As the general arts of traditional Ryukuan culture reflect many diverse Asiatic influences, the colourful patterns of BINGATA stencil-dyed cloth is based on designs borrowed and rearranged from neighboring China, Japan and SEAsia. Javanese batik lent much of its technology to the origins of bingata cloth but this already atop a native knowledge of both weaving and dying. Indigenous technology adapted freely from any and all sources but the strong colours seem most reminiscent of the brilliant natural shades one can view with ease all over these tropical islands. Sky blues of vibrant strengths, the hues of brightly tinted fishes and plumed tropical birds amid flower bedecked greenery are all captured in flowing repetitive bingata design. Colours used in dying come from locally available sources: yellow from a special tree bark, red from a cactus eating insect and blue from wild indigo.

The method of stenciling is quite special with gradated colour one of the remarkable characteristics. Strong shades blending into one another within very small spaces. Such craftsmanship takes enormous skill not to mention time.

Although today one can find all levels of society clothed in bingata kimono on special occasions, it used to be reserved for the Okinawan aristocracy and limited overseas trade. As is typical with many Asiatic nations and of course with some older monarchical Western cultures, certain colours denoted rank with the deep corn yellow background bingata worn only by the ruling family.

Today one finds bingata used in a variety of ways, even framed as pictures they're so lovely to view. Bingata is shown on page 122.

KAMI-GUNKAN

O ne hardly expects to find a war memento in the world of mingei but KAMI-GUNKAN are just that although much diminished with passage of time. A wheeled lantern, this wood and bamboo frame is covered with paper painted to resemble a turn-of-the-century warship such as fought in decisive sea battles of the Russo-Japanese War (1904/5). This conflict was eventually settled through the intervention of United States President Theodore Roosevelt in the Treaty of Portmouth but the success of Japan in this second war (she had ten years earlier won a conflict with China over hegemony in the Korean penninsula) elevated her international standing considerably. In less than a half century, the feudal nation had become a world power with a remarkable economic base and a potent military ability.

Back to the making of these lanterns, the first such military boat toys were well over a metre long. It is felt that the custom of giving children lanterns in various shapes to play with on summer nights during the season of Bon, a festival honoring ancestors, is the basic origin of this particular boat lantern. Obon chochin are used to welcome back the spirits of departed ancestors by lighting their way to and from the spiritworld. After ceremonies for the dead, the lanterns often become the playtoys of children especially in their myriad charming shapes: goldfish, sea bream and the like.

The height of national fervor over their victory at sea during the Russian conflict happened when the Bon season was drawing near. And thus replicas of the steamer warships that had fought in those sea battles came to be lantern carts complete with mast and flags flying.

They were primarily given to young boys who reenacted battles with their metre-long toys lit from within and shining brightly as their coursed over nightime "seas". Current models have come to grips with their original inordinate size, and although they retain all the painted imagery of ships under steam, they are nowadays a more manageable and compact 30 cm in length, as shown in the colour plate on page 123.

ZARU-KABURI-INU

The Edo era spawned many folk toys. Why? Being a time of relative calm throughout the nation, people both traveled and prospered — two aspects of economic life that encourage small business enterprise. And Edo (what is now called Tokyo) was the center of Japanese life, although the physical center and spiritual center were both far away from this "new" capital.

There are a great many stories dating from the Edo era concerning the loyalty of dogs. One of the most famous is "The Hakkenden" (Tale of Eight Dogs) written by Bakin. This involved tale took the noted novelist 27 years to complete by which time he had become blind.

Another interesting tale concerning dogs is credited to Kobo Daishi, the reform—minded Buddhist priest. On a pilgrimage in Shikoku, he stopped overnight at a local farmer's home. Pleased with the devoted services of the farmer, he said he would comply with any request made. Troubled by boars in his fields, the farmer asked for a charm to protect his crops. Kobo Daishi took up a writing brush and created a paper charm, which he folded, sealed and handed the farmer, telling him to hang it in his fields. The curious farmer eventually opened the highly efficacious amulet and the dog the celebrated priest had penned therein immediately flew away. This is thought to be the origin of Inu-gami or the dog god. The main shrine to this god is found in Nara, but many others venerate the dog as a guardian diety.

Asakusa in Tokyo is particularly well known for this toy — INU-HARIKO or ZARU-KABURI-INU. Usually presented to new babies when they make their first trip to the family shrine, several varieties exist of these papier-mache dogs. One has a small den-den daiko (drum rattle) belted with a strip of cloth to its back. Hung as a charm near the baby's bed, the drum is often given the child to play with while the dog keeps vigilant watch.

Another style has the dog suspended by a strip of paper threaded through the dog's nose. This charm is thought to prevent respiratory illness in babies and bring them good health during the highly dangerous (healthwise) first years.

But the basket-hatted dog shown is perhaps among the best known of these small images. Brightly hued, this puppy jauntily wears a small basket he has been playing with to the amusement of all. It is a combination watch-dog and toy to be hung above the baby to care for him in sleep and enchant him while awake.

ITA-SUMO

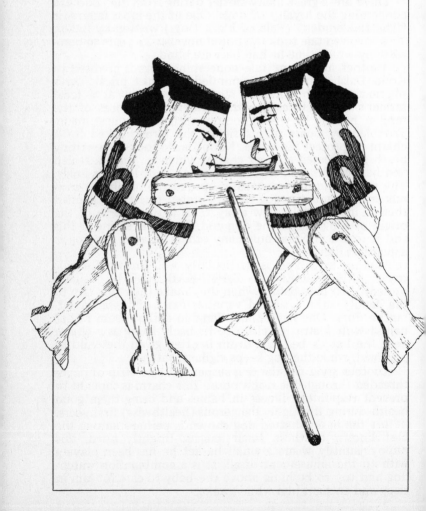

This mingeihin's correct title is HIGO-NO-ITA-KAKU-RIKI which translates to read board sumo from Higo. Kaku-riki is a sumo term that has to do with power-packed wrestling. And anyone who's ever seen a sumo match has to agree it is a power-packed meeting of two gigantic adversaries.

Higo in Kumamoto Prefecture on the island of Kyushu is where this toy amulet orginated in the Edo period when sumo tourneys began to travel throughout the land as a spectator sport. Sumo itself has a history dating back some 2,000 years and has long been regarded as the national sport of Japan although modern baseball seems to be giving it a distinctly hard time these days.

Sumo wrestlers are gigantic and have girths that amaze the on-looker. They consume great quantities of food and sake, which seems quite contrary to the style of training the West requires of its athletes. But then sumoists are hardly average athletes!

Underneath what seems to be fat is actually a hardy muscular structure that gives them great power and flexibility in the ring. Most of the rules of sumo are based on principles of leverage, and excess weight counts to great advantage. There are 48 paramount rules governing 12 throws, 12 twists and 12 backward shoves used by these behemoths of sumo in their quickly fought battles inside the ring. Most actual contests last less than a minute, although the period for mental preparation may easily take a quarter of an hour. The reason for this long get-ready is to have matched psychological preparation on the part of both wrestlers, giving them an even footing at the start.

The Higo toy is made of paulownia or kiri — a very light-toned wood which is traditionally called the empress' tree. Paulownia leaves generally make up the insignia of her family crest. The wood is also very light; when it is sliced into such thin boards as are used for this toy, it is much like balsa. The locked arms and dangling legs are attached with knotted cords. Action is initiated by moving the pole centered on the shoulder-high clinch. Simple details, such as facial features and the decorative loin cloths are painted in. Hours of fun for youngsters and day dreams of success for budding yokozuna, no doubt have much to do with making this unusual toy so popular.

OKESA-GOMA

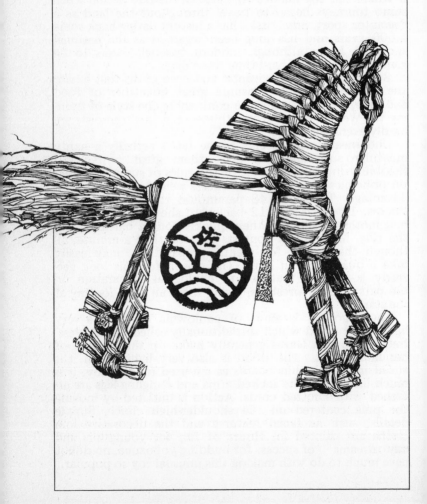

Horses are the symbol for the seventh year of the Oriental zodiac. Chronologically, horse trappings have been found in ancient dolmen and mentioned in regard to the death of the Emperor Suinin (29 B.C. 70 A.D.). Instead of living sacrifices being interred with the departed emperor, terra-cotta images (haniwa) of men, horses and assorted other items and animals were used.

Japanese horses for the most part were rather small but feisty animals until European breeding stock was introduced in the early part of the 1600s. These stallions arrived in Japan just after the edict against foreign goods was promulgated. Hasekura Rokuyemon, who had gone to Europe as a special envoy of the Date clan from Sendai, brought them with him on his return in 1620. Since they were "forbidden," the Date chieftain drove them out of his territory into the convenient hands of his neighbors, the Nambu clan, who caught them easily. Regarding them as strays, they soon found their clan-fame resting in part on the strength and virility of their fine mounts.

OKESA-GOMA are made of woven and knotted straw. Besides being a child's toy, it is thought to have special properties needed to protect its owner against evil spirits. These straw horses are made each year in the village of Shimebari on the isle of Sado in the Japan Sea. The island was formerly used as a place of exile and no doubt locals thought it expedient to protect themselves against devils from any and every source. The horses are taken to the local Shinto shrine for dedication, and one is then suspended from the guardian rope marker hung at the entrance to the village, while others go into individual homes.

Each steed is supplied with a red paper blanket on which is imprinted a coin with the character "sa" (as in Sado). The economic level of the village surely created this paper money as a substitute for the absent real thing.

Okesa-goma derives its name from a folk tale concerning a poor noodlemaker and his wife who were aided Puss'n' Boots style by a cat which changed into a daughter for the childless couple. Okesa was her name and it is now given to any number of items from Sadogashima. Goma is another reading of the character uma meaning small horse or foal.

SUSUKI-MIMIZUKU

Fukuro yo,
Tsurakuse naose
Haru no ame.

This haiku by the famed Issa (1763 — 1827) purports to be advice from a dove telling his friend the owl to change his look because the spring rains have begun. Rains may have indeed begun falling but one thing is sure, the owl seldom if ever changes his expression.

Consistently dour faced, the owl this mingeihin is modeled after is called a MIMIZUKU (eared owl) for the tufts of feathers that resemble auditory units. Made of susuki (pampas grass) seed heads collected in late summer and early autumn, this folk toy is a Tokyo item originating at Zoshigaya's Kishibojin, a shrine devoted to the Goddess of children. The Musashino Plains which come right into Tokyo were once famed for waving fields of susuki, and many are the haiku written on that subject too!

It seems that 250-odd-years ago a widow and her young daughter lived nearby Kishibojin Shrine. The mother became very ill and without money to buy medicine. The young daughter went daily to pray for her recovery at the shrine. On the twenty-first day of her Mother's illness, the tired youngster fell asleep after praying. The Goddess appeared to her in a dream suggesting she gather some of the seeding susuki heads to fashion mimizuku amulets to sell to shrine visitors. That's exactly what she did, and when they were all sold, she had money for medicine plus a new livelihood for herself and her aged parent.

The owls are made of simply tied bunches of the seed heads, with a small red streamer saying Kishibojin and Zoshigaya. They are combination amulets and toys although their primary purpose is to protect owners from illness. There is also a slightly larger style — a mother owl with two owlets tucked into her wing folds, along with the original illustrated here. Mimizuku are yet another Edo era mingeihin to span the years despite urban changes. But one has to go far afield these days to see or collect susuki fronds enough to produce them.

ITO-MARI

I TO-MARI, which directly translates as thread ball, are found in every prefecture from Hokkaido to Okinawa, with a multitude of complex designs that are unique patterns of intricate color created with fine threads.

The first thread ball was no doubt a toy of invention. Silken threads salvaged from old garments were used to make the earliest such ito-mari, but by the mid-Edo era, when cotton was both fairly cheap and widely sold, ito-mari began to have a more plebeian life and its popularity spread quickly.

Along with popularity came a tradition that is still widely practised. Come the end of the year, a mother will secretly begin to wind a ball and plan a pattern. By the last day of the old year she is nearing completion and when the young lady of the house awakes New Year's Day, there by her pillow will be a new ito-mari of near magical design.

Before the advent of mass media, patterns were mainly regional styles with variations centering on one central design. Some of these patterns have acquired names of flowers such as kiku(chrysanthemum)or ume (plum) while others have taken names of natural patterns they resemble: shooting stars, fireworks, wandering streams, autumn leaves, to name but a few.

The ito-mari is mainly a throwing ball given young ladies to play with near their homes. Catch doesn't need a bouncy ball and rubber hadn't yet made an appearance when these uniquely patterned toys first took hold. The central core of each is merely tightly wound thread. When the desired size is near, the maker begins to give special attention to the intricate manner in which she winds each successive thread, carefully choosing not only its color but also the direction and length it will have. By using large curved needles, it is fairly easy to perfectly arrange a complex geometric pattern that could be peculiar to that district or one that a daughter wistfully mentioned. Colors may follow district customs but then they too (often as not) followed the whim of the maker.

Today one finds these balls used more as a hanging decorative object than for catch. Considering how attractive the many variations are and the wide spectrum of colors they come in, it isn't surprising. See colour plate on page 118 for variety of examples.

EMA

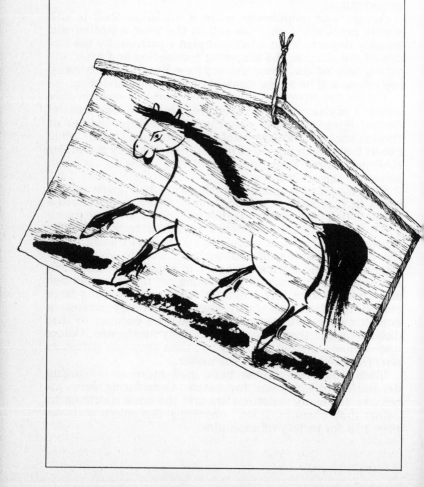

These votive plaques date to the reign of the Emperor Suinin. It was this ancient leader that instituted the use of clay images or haniwa in lieu of live burials when tombs were built for the wealthy. Horses previously interred then came to be gifts to shrines. These "shimme" were literally thought to be horses for the god to ride. It wasn't long before these "gift horses" became more trouble than they were worth. The next logical step then was the making of replica mounts on the same idea as those ordered by the emperor in years not long past.

Shimme are still present in some of the largest shrines where they lead a life of luxury in stables situated within the grounds of the god's earthly abode. But invariably, a second building is not far away — the ema-do, a repository specifically constructed to hold and display the many votive plaques gifted the shrine over the years.

The term EMA literally means picture horse but no longer is it exactly accurate. The earliest such pictoral representations were no doubt just horse drawings but the range has widened considerably since then without a change in name. So, regardless of the figure or object portrayed, plaques are still called ema.

Some temples and shrines have famous ema created by artistic masters of their times. But the majority were and are simply fashioned in the shape of a gabled two-dimensional stable with a prancing steed or two inside.

Prayers for intercession accompany each ema gifted a temple or shrine and the variety of designs echoes the variety of pleas sent the god's notice. Horses are still highly popular themes — free running or with foal, with some garbed in the heavy protective gear samurai mounts used to wear into battle.

Pictures of the god's themselves are also popular but so too are items particularly associated with each individual god(dess). For example, a harp is typically offered to Benten (the Japanese equal of Venus) and a dove (?) represents Hachiman — the God of War.

Literally, almost anything can be found on ema including full-bellied pregnant women kneeling in prayer at a torii, ever-smoking incense jars, kanji (especially elaborate calligraphic ones), or even slightly ludicrous items one hopes the gods will keep you away from — things like sake bottles and dice. Ema are literally an art of the common folk which is just what mingei is after all. Some are shown in colour on page 133.

SUMI-TSUBO

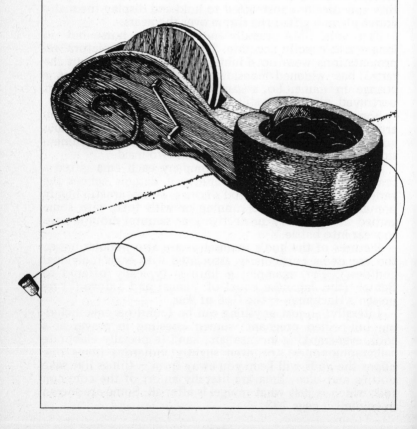

If one is lucky enough to see carpenters at work in Japan, you will no doubt have the opportunity to see them use this item — SUMI-TSUBO. These line marker are found throughout Japan with slight variation in design but essentially the same basic form. Without the straight lines they produce, Japanese architecture might well be less impressive.

Many countries have similar aids for making long and perfectly straight lines, but those found in Japan are marvelous combinations of exquisite beauty and remarkable function. Sumi-tsubo literally reads ink-pot in translation, but they are much more than just receptacles for blacking. The wheel that is partially visible holds a line of twisted linen. This line is fed off that spool into the pod-like end and out through a hole where it is permanently attached to a stickpin. The pod is where the blacking is kept soaked into a wad of cotton. Running the string through this well gives it a coating of black which, when properly positioned, can be transferred to the wood to be cut. Most everyone who sees this being done thinks anyone could do it but not so! This is an expert's tool that needs very much an expert touch to function properly.

The carpenter positions the stickpin where one end of the cutting line should be and unwinding the soaked string quickly from his sumi-tsubo, moves to the correct location for the opposite end of the line. The line is kept in the air until almost the last second. Speed is also important as the sumi (Chinese ink blacking) will dry out and no line will transfer. By knowing exactly what he must do beforehand, the daiku (carpenter) is soon ready to both lower the wetted string into place and give it a firm pluck. Just once not too light nor too hard! The reverberations of that pluck travel the length of the marking thread and deposit the load of ink it carries on the surface where it is laid.

The thread is rewound on the spool, ready for another job while the carpenter readies to cut along his newly laid mark. A small item that has played a pivotal role in developing Japanese architecture down through the years, sumi-tsubo are yet another mingeihin that bridge the years with ease.

Those made in Kyoto are particularly well-known with many having ornate tsuru and kame (stork and tortoise) motifs carved into their hardwood surfaces. Keyaki (zelkova wood) is especially prized for both fine grain and durability.

HAGOITA

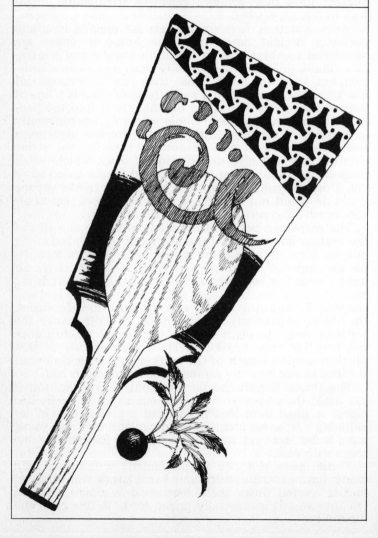

HAGOITA, or battledore, are popular items throughout Japan. The game itself, oibane in Japanese, is believed to have been imported from China. An amusing version of the origin of this game has to do with mosquitoes — the nemesis of summertime. Dragonflies are great admirers of their lowly cousins, so much so that they devour them by the hundreds everyday when in season. Since the shuttlecock (the feathered and weighted "ball") resembles the dragonfly in flight, it was thought the playing of oibane was a charm for the proliferation of dragonflies and the demise of many, many mosquitoes!

The game is now generally associated with New Year's and just prior to that season one will find many festivals featuring lavishly ornamented hagoita. The game is also felt to be a girls' game and so the majority of hagoita are decorated with patterns that would appeal to young ladies.

Since most young girls dress in kimono for the New Year celebrations, the rules of oibane are really worth mentioning. The shuttlecock is batted to and fro with the player missing the most shots being branded at the end of each set with a smudge of charcoal on her face. Imagine, if you will, a colorfully clad maiden, with her hair especially styled, being smudged with a dab of black on her forehead as a loser's penalty.

It used to be that battledore were sold at shrines celebrating fire festivals (Hi-matsuri) with those hagoita especially patterned with fireproofing charms. Another style called kyuchu, which means "inside the palace," generally show a courtly emperor seated before a bevy of ladies or perhaps musing under a lofty pine.

Those made nowadays tend to be heavily burdened with layers of oshie (cloth covered paper collages) depicting famous actors from the world of kabuki. These battledore are mostly for show being displayed on a stand in the tokonoma during the New Year holidays. Still some are simply fashioned with painted patterns and perhaps a portion of chiyogami like the one illustrated. The rice ladle (shamoji) that is central to this particular design identifies it as coming from Miyajima in Hiroshima-ken even though you may not be able to read the kanji. The top of the scoop also resembles a rising sun while the curlicue design breaking across that orb brings to mind the waves upon which the shrine floats so serenely in the Seto Inland Sea.

TENGU

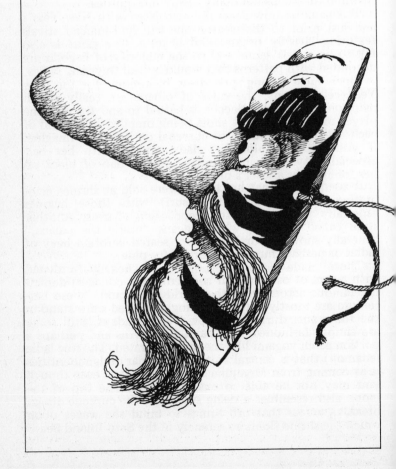

TENGU masks always bring a chuckle and a blush to the first-time viewer. Their long, crimson bright noses seem to be in that special class Cyrano got tagged with, only tengu noses are more obscene. They're in fact prankish goblins who like to live deep in the forests or high in the mountains away from people who pry. The occasional passer-by is more the type of company or prey they prefer. Besides abnormally long proboscis and human mouths, tengu are thought to sport luxuriant beards.

One legend having to do with the origin of tengu has them arriving in Japan adrift in a boat. With lots of facial hair and red, sun-burned faces, these "European" sailors seemed also to have enormous noses. In comparison to the average Japanese nose, it might well be they did seem overly large but 20 or 25 centimeters? Anyhow, the wiles of passing years have given us tengu with monstrous noses and skin pigmented so brightly red that a bull would be startled. With black and fearsomely bushy eyebrows and facial hair, the tengu face is complete.

They are often portrayed as having large flowing capes and carrying fans made from the leaves of yatsude, a bushy plant commonly cultivated throughout Japan. Its name-giving characteristic are the eight (yatsu) fingers (de or te) on each leaf. Tengu carry these yatsude fans for several reasons, including flying and for balancing on their peculiar geta. Geta with but a single and very tall supporting spoke dead center. Sort of like stilts that make them very tall. Another leftover from the original perhaps!

Many festivals are enacted in their name. In fact, for some unexplained reason, tengu have come to be reverred as patron saints of farmers who have in turn made many a tengu-dedicated temple into a lavishly ornamented show-place. Buying time is perhaps unkind but when you consider they are nothing more than glorified goblins who'd as soon rip off your prize porker as steer you over a cliff, what else can you surmise?

Whenever or wherever you meet with one, keep your wits about you. If all the stories passed down through the centuries are any indication of things to come, you're surely in for a rough situation that will get better only with each retelling should you live to recount it at all! Tengu masks, for use in religious ceremonies, are found in several prefectures but those of Fukushima-ken are especially prized as being the most authentic. Since we haven't had a vote from the side that counts, I think I'll just pass that on.

SOBA-CHOKO

These small porcelain cups are truly a link to Japanese folk art, especially when one considers the tons of porcelains made in Arita. Very few Arita pieces can still claim kinship to the simpler porcelains of years long past but these small soup cups are an enduring reminder of what Arita is all about.

Porcelain manufacture in Japan really began in 1515 when Shonzui Gorodayu returned from ceramic studies in China. With the secret of porcelain making in his grasp and with imported materials (from China of course) he produced fairly good native work but with the end of those supplies and his death in 1550 production stopped. It didn't resume until the early 1600s when Risampei, an impressed Korean potter, discovered the necessary kaolin clay in large quantities at Arita in Saga-ken. This clay, called Izumiyama-ishi by potters, allowed an industry to be born that has made itself felt around the world.

Getting back to the first potters, being Koreans by birth, their work naturally tended to resemble Yi Dynasty wares. Pressure was brought to bear by controlling parties to produce wares more like those of the Ming Dynasty in China. Eventually Arita potters did them one better and began producing wares not only equal to Ming styles but more highly colored and complexly patterned. But still, they did not forget how to make wares ordinary folk would use and want. Such is the case with this soup cup.

I have heard these choko referred to as "humble," which is far, far from the mark. They are strongly utilitarian but that too is a harsh and unsympathetic term. Maybe it's because I've seen several collections of old and new pieces that I feel they deserve the adjective "elegant." Almost without exception their straightsided forms have pure cobalt patterns decoratively painted over the outer surfaces and with quiet restraint on the inner. A small character or floral pattern typically dead-centers the inner cup floor while the inner rim is banded with a repetitive motif. They tend to be of two nesting sizes.

Cooked soba (buckwheat noodles) are served on trays with draining bamboo racks. Hot or cold noodles taken from their serving dishes are dipped in SOBA-CHOKO before being slurped to oblivion with gusto. One need only hear the obvious relish soba eaters entertain about these noodles to know that soba-choko will surely be one of the last folk art links to disappear from everyday Japanese life.

NEPUTA-CHOCHIN

Neputa Matsuri is one of Japan's most famed festivals. The reason behind the yearly display of massive lighted floats is based on an actual event that occurred 1,000-odd years ago. About 800 A.D., the emperor dispatched one of his ablest generals to the northern territories to quell the Ainu and expand the hold of the Yamato Court. That general, Sakanoue-no-Tamuramaro, in a series of masterly battles routed the troublesome native inhabitants. In the course of his long Tohoku campaign, he devised several "new" methods of gaining favor with the gods and also pulled off more than a few good tricks. Neputa floats were one trick that worked perfectly.

Undermanned and facing a strong host of fierce Ainu warriors while in Honshu's northermost prefecture — Aomori-ken, Sakanoue ordered his forces to create a number of large paper warriors and mounts. Lit from inside their fragile lanternlike bamboo structure, these giants thoroughly frightened the Ainu into a retreat which eventually took them clear across to Hokkaido.

The victorious general had once again come through with an unusual solution to a vexing problem.

Years have added to the reasons behind the annual display of NEPUTA CHOCHIN. One of the more important is the association of these lighted figures with midsummer sleeplessness. In fact, the term neputa is a corruption of nemutai which means sleepy. By throwing away these disposable paper creations after they've been paraded about city streets for nearly a week, one gains protection against heat sleepiness that disturbs both your work and life.

The huge floats are not destroyed each year but smaller versions are! They and hundreds of smaller lanterns in the shape of colorful goldfish, each lighted from within by a small candle, are cast into the river or sea to take away sleeplessness (and foggy thinking).

But for nearly the whole first week of August in both Aomori-shi and nearby Hirosaki one can see all sizes and shapes of neputa-chochin, from the great wheeled figurines to tiny kingyo, moving through the black sea of night accompanied by the almost incessant rythmic beat of numerous drums and flutes. Maybe, just maybe, it's their noise that drives away sleepy feelings but then again it could just be these unusual lanterns that do the trick.

KIBAZARU

K IBAZARU is best rendered to English by reading mountain monkey. Kiba itself means tree leaf but in Kumamoto-ken, where this statuette originated, Kiba was a mountain area where several families lived in isolation. Over a thousand years ago, one of the families had a disturbing dream come to them on New Year's Eve. Shogatsu dreams are regarded as portents of the future and the superstitions of these simple folk were aroused by the recounting of this particular dream.

It seems an old, old man appeared in this dream telling the villagers they had best appease the gods enshrined in Nara's famed Kasuga Jinja. And the way to do so was to fashion ceremonial vessels of red clay! This the villagers of Kiba did using clays from the encircling mountains. Left-over clay was thrown away and to the amazement of all, it turned into a monkey that scampered into the woods. Then to compound their fright and surprise, a tengu appeared with further instructions on how to fully appease the Kasuga deities.

He suggested that henceforth, when they made offering pottery for their shrine, they should also fashion clay monkeys. These figurines, both male and female, would not only please the gods but also serve to protect the health and future generations of these remotely situated families.

And so another rustic fertility symbol was created to add to the many others found throughout Japan. The female Kibazaru clutches a baby to her breast while the male supports an oversize phallus. These clay figurines are displayed on the kamidana (god shelf) in the home. They are appeals to the Kasuga gods for sons, healthy children and safe childbirth. Most sexually oriented mingei have similar beliefs surrounding their origins, although none so charming in legend or reality as this small figure.

SOMIN-SHORAI

The true history of this amulet is rather hazy about just when it all began, so let's stick with long, long ago. The emperor and some of his retinue were off to see a lovely lady who lived some distance away. The journey took much longer than expected and they found themselves without a place to stay for the night.

Spying a rather well-kept and prosperous house, attendents inquired if it would be possible for the emperor and his traveling companions to spend the night there. The answer was an emphatic NO! Nearby was another house nowhere near as imposing or prosperous looking, but any port in a storm so ... and the answer was "Please be my guest." In fact, despite the mean circumstances of the home's owner, one Somin Shorai, the emperor and his retinue were treated most royally. They departed the next day with much good will toward the courteous and helpful host of the past evening.

It seems that the lady was much impressed with the suit pressed by the emperor and was soon his consort. They had eight sons altogether before the emperor and his empress found cause to follow the same route he had traveled so long before. Remembering the gracious host of that unexpected break in his journey, he ventured to call at the same home once more.

He was received in like manner once more and in return let his host, the same Somin Shorai, in on several ways to protect the health of his family. One of these "secrets" was to make a peg of peeled potato and wear it on the waist cord of your kimono.

Anyhow, the story continues to explain that the house of wealth belonged to his younger brother, a pompous, stingy fellow who quarreled with everyone. When the village was struck with a plague, everyone except Somin Shorai and his immediate family died. In thanks they built a shrine to the memory of the emperor, small versions of which are now found throughout Japan. Amulets like the one pictured honor the memory of the first Somin Shorai and ask for protection for all his descendents, i.e., everyone who takes an interest in this case of the gracious host and his unexpected rewards from being so kind!

Simply decorated with alternate black and red segments on each of the six sides, kanji about the top ask for intercession on behalf of all Somin Shorai shison (descendants). They are usually kept on the kamidana when brought into the home.

SAKURA-KAWA-ZAIKU

The use of peeled cherry bark for wares has a long history in this part of Asia. Cherry trees here are especially favored for their delicate but short-lived blooms in the spring and many are the poems that glorify the pinky cast they shed over springtime mountain views. One I particularly favor is by the Zen master, Ryokan:

How can we ever lose interest in life?
Spring has come again
And cherry trees bloom in the mountains.

The flower is used as a crest mark, for making special tea, and in many designs whenever the thought of springtime or youth is desired. Leaves too are used for special sweets, but most Japanese flowering cherries don't have fruit worth mentioning; their primary glory is in flowering so magnificently. Still, there is the lustrous and extremely strong bark of the yamazakura (mountain cherry) which is used in a myriad ways. The history of using cherry bark thus goes back many hundred of years. In fact, items of great historical value using cherry bark are to be found in the Shosoin repository at Nara. These items were made for imperial use over 1,200 years ago.

There are also numerous references to bark covered goods in the early literature of Japan. In those times it was especially favored for use on sword cases and on bows because bark rejects humidity changes and protects the wood it covers from becoming uselessly brittle.

Today, one finds it on a wide variety of items — everything from tea canisters like the one shown here to letter boxes and tobacco cases. Every so often, if you frequent antique shops, you'll come across bark covered inro (medicine case) or kiseru (long-stemmed pipe). These and almost anything demanding long life have used cherry bark and can be found executed in this unusual covering.

Every autumn the licensed collectors collect plates of bark from live mountain trees. This process demands special care so as not to damage the tree. Only a very thin veneer of bark is lifted so the tree is left to form a new skin for the sure-to-arrive spring with its bounty of flowers.

Cherry bark work seems to center on Akita-ken in Tohoku, but is found spread throughout the whole of Japan. The highest quality wares use only 100 percent bark to fashion items, while durable but cheaper goods use a thin bark veneer over assorted wood, metal and even plastic bases. A colour photo is on page 135.

TEFUKI GLASS

Glass is almost totally ignored by most mingei specialists because they erroneously assume it is both an imported art form and too new. Nothing could be farther from the truth. The history of glass production in Japan apparently goes back nearly 2,000 years when small but delicate items were made to adorn reliquaries and other temple regalia. A show outlining the history of Japanese glassware was held not long back in Kamakura's Museum of Modern Art. The viewing public was astounded to see such a diverse range of goods with such a lengthy production history.

Glass made in the folk art tradition is not common throughout Japan but is found in at least four locations. One, of course, is in Okinawa where relatively new glass ovens turn out a plethora of shapes using recycled bottles which are color divided and melted for reshaping. The occupation of Okinawa following the Pacific War's end gave rise to this industry — the occupation bringing with it the benefits(?) of nonreturnable soft-drink bottles which eventually found their way into the glass industry there.

Kurashiki is another center of traditional glassware. It is made quite openly there, in Japan's version of "Williamsburg," by Shinzo Kotani and his assistants. Finer in quality than its Okinawan cousins, Kurashiki glass is handblown freeform and moulded. The bottle's squared sides were paddled into straightness from a freeform bulbous bottle shape, while the indentation patterned drinking glass was forceformed in a simple mould. Kurashiki colors are less garish than Okinawan tones but then these colours are formulated from scratch.

Other glass production centers are in the Kanto plains (both Tokyo and Yokohama) by assorted artisans and in Tohoku, primarily around Aomori, where the main line of production wares in the north has been the making of glass floats (ukidama) until fairly recently. Introduction of cheaper plastic floats has severely cut into that line's sales so some of the companies are branching out to make a variety of functional glasswares in mingei styles.

In true folk art style, little, if any, of the glass made till recently was signed, but pride in workmanship has brought about a change there too. Pieces today are often signed.

HINOKI-BENTO

There isn't a season on picnicking in Japan and neither is there a special style lunch necessary to find it neatly packed in one of the these convenient wooden boxes called BENTO-BAKO. No one says you must use these specially crafted boxes only for lunch but that is their original purpose. People who traveled away from home for almost any and every reason took their own lunch and/or dinner with them or they went without. Farmers off to distant fields for the day took bento-bako along for their noon repast as did students off to school, those off the trade and/or sell at the local markets and the average man who went anywhere far enough that he wouldn't be home to eat a meal.

Things are a lot different these days but nevertheless one still finds bento being toted to offices by cost-conscious young husbands who dream of their own home or apartment in the near furture, by young girls who long for a certain new style dress that only fits their budget if they skimp a bit here and there, and increasingly by those concerned with the wholesomeness of the food they can buy conveniently but not very cheaply near their work.

Tohoku is where one most easily finds the best bento-bako. They are mostly made of hinoki (Japanese cypress) but occasionally sugi (Japanese cedar) is used, with its inner surfaces carefully lacquer-lined to protect foodstuffs from the strong aroma of raw cedar wood. Hinoki boxes like the one pictured are made of thin shakes cut with the grain that can be steam bent or heat formed into smooth round curves. An incised groove about the edge of one inner side of each shake will keep the floor unit in place once ties of cherry bark are laced in.

Lids are made slightly larger than bases so they fit easily over top one another. A variety of shapes are made to suit all tastes — varied sizes too for all sort of appetites. Large round drum size hinoki–bako with shallow lids are made for keeping freshly cooked rice in at the table or for porting it along on a family journey where more than one mouth need be fed.

Smoothly skivved and fresh smelling, these simple wooden cases typically originate in either Fukushima or Iwate Prefectures where good stands of native cypress are found along with the skilled craftsman needed for preparing the shakes and bending them just so to make gracefully functional and long-lasting bento-bako.

BEIGOMA

Marbles are a Western child's summer toy. Hardly does anyone grow up without a fleeting romance with the notion of a grand sweep of all the neighborhood marbles, especially those of the local "champion." The same holds true for Japan but it isn't marbles that command such respect and attention and neither is this offering strictly summertime fare. Fighting tops go by the nomer of BEIGOMA. That means shell top (as in spinning top) and the shell patterned base is a fairly true copy of the common periwinkle. These sturdy tops(?) are misnamed for sure because they certainly were never meant to spin wildly to any string-puller's tune. Made of cast iron with a spiraled base and either a raised letter of the alphabet, hiragana or kanji, they are really miniature weapons. Their toughness is necessary because playing beigoma is far rougher a game than marbles, although the two are quite similar in rules and playing mannerisms.

As mentioned before, beigoma are nonseasonal. Any shallow indentation etched in the ground will suffice. The playing field is a circle inscribed about this indented area.

It takes at least two to play but the more the merrier and greater the possible booty will be for the victor. Each player tosses one of his beigoma into the circle in turn. Stone, paper, scissors (jan-ken-pon) is the usual determinate of playing order. First one in is right off at a disadvantage as subsequent players try to literally knock the first top from the playing ring. Windups and careful throws are all part of the game, which pits your aim and strength at pitching a beigoma onto the playing field against that of the other players.

Each beigoma throw tries to force the other players' pieces from the ring so they'll cease to be theirs and from henceforth will be yours. Those with a good eye, excellent aim and a good backup supply of fighting tops can soon have a substantial hoard of the same.

Thinking back on how often I lost really good aggies and steelies to better marble shooters, I wonder if I'd have fared any better at shooting beigoma. I doubt it so I'll hang onto the few I have, regardless of how much the local elementary school kids entreat me to play. I must look like an easy mark!

Beigoma were made almost everywhere that the smelting of iron was done, although few establishments still turn them out nowadays.

SUZURI

SUZURI are an imported folk art object that have become an indispensable part of Japanese life and culture. Without suzuri, writing with a fude might well not have originated and the world would lack for the intricacy and loveliness that Eastern calligraphy entails.

Although most of the earliest suzuri came from China, it wasn't long before local artisans had found the right type of stone (finegrained slate) to begin making a home-styled variety. Most were simple in design and not like the highly embellished Chinese pieces that often had fierce dragons cavorting about the well and rubbing surface.

Inkstones must have two features whatever other form they follow: a shallow collecting well that slopes onto a broad and extraordinarily smooth rubbing surface. Indian or Chinese ink is produced in stick form in another artful process that was imported to Japan centuries ago. Sumi, as these sticks are referred to, must be ground into a soluble solution. This is done by wetting one end and carefully rubbing it over the instone. The depth of tone the ink has depends on how much ink is rubbed from the stick.

Ink, when completed, is exactly the consistency that the writer prefers. It might be well to note that there is a wide latitude here — some preferring paler, grey tones while others must have a deep, rich black. The rubbing surface becomes a straightening plane where the ink-filled brush tip is reshaped to a careful point and dripping excesses are carefully removed. The slope takes excess ink back to the well again.

Shapes have become far more diversified in recent years. My own favorite has rough edges with a perfect circle rubbing surface. The well appears to be a crescent moon to one side. Another I have is as small as my thumb. A narrow rectangle that came in a lacquered carry box with two-part fude and small a stick of sumi — the travelers' companion.

The shell shaped stone illustrated was exhibited in a recent Japan National Traditional Crafts Exhibition, a good example of just how diverse styles are.

Stone deposits just right for making suzuri are found in numerous locations throughout Japan, but several calligraphers emphatically state the best are from Kyushu. Then some just as vehemently say the best are at least 100 years old and well used. So it stands to reason you should try to get an antique suzuri cut from Kyushu slate!

SHU-ROSOKU

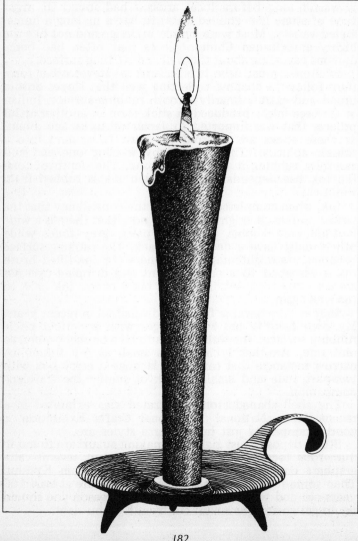

It is thought that the best candles come from the district of folk medicines — Toyama-ken. Just why is explained by a rather touching folk tale.

It seems that the sea off the coast of Toyama is populated with mermaids. But since this tale's sad ending, they are seldom seen. One of the more thoughtful mermaids wished that her soon-to-be-born child might have a better life. She wanted it to grow up not in the sea but on the land that she gazed upon each day and night from her rocky perch.

When it came time to give birth, the mother dragged herself ashore and laboriously climbed the steep steps of a shrine near the beach. She left her new baby there, trusting someone would find and raise it as his or her own.

It happened that every evening an old lady from the village, who together with her husband made the candles travellers presented at the shrine, went there to pray and thank the gods for their livelihood. On her way back from her evening pilgrimage, she happened on the tiny mermaid. Taking the baby home, she and her husband decided the child must have been a gift from the gods and that they would raise her as their own.

She grew up to be a lovely young lady but because of her nether half being a fish, she never played with any of the other village children. She became, however, most adept at the old couple's trade — making candles. In fact, the first white candles to be decorated with flowers and leaves were done by her. Delicate drawings soon became very popular and made life for the three quite comfortable.

A band of ragtag sideshow people happened to hear of this mermaid and wanted to have her in their menagerie. After repeated offers of handsome sums, the old couple were persuaded to give up their daughter. When the circus people came to claim her, she begged and pleaded with them to allow her to finish the few candles she was working on. They roughly dragged her from her bench as she grasped the last few candles to be decorated and dipped them into the red wax pot.

Shipped far away from Toyama, her parting cries were heard by her real mother who in retaliation had the gods of sea and storm lash the coast with a ferocious typhoon. The shrine was wrecked, the old couple's livelihood destroyed and SHU-ROSOKU came to symbolize the unhappy fate of everyone tainted by greed.

JIZO-SAMA

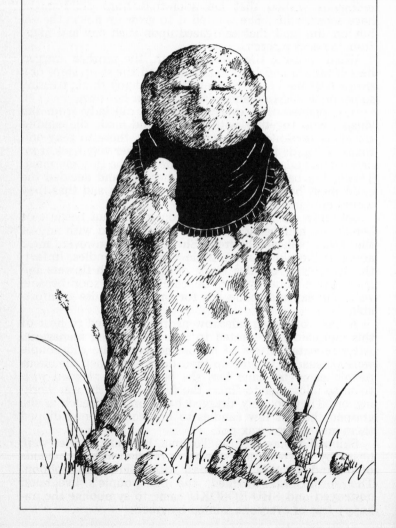

Throughout Japan one of the most common personages to meet on a most any.highway or byway is O-JIZO-SAN.

Just who is or was Jizo? His name in Sanskrit is Ksitigarbha, but unless one is quite expert in the lore of Indian dieties, that is of little assistance. Perhaps the analogy of making Jizo a children's Saint Christopher is more understandable.

According to Buddhist beliefs, souls of all dead children must go to Sai-no-kawara, a river that separates them from Paradise. There on the banks of this unpassable river a witch, Shozuka-no-baba, steals their clothing and sets them to piling stones into towering heaps. She tells them to build these towers in order to climb to Paradise. A cruel joke because the flimsy rock piles are regularly overturned by the witch and her devilish band.

Jizo, the patron saint and guardian of small children, comes to their rescue and chases the hag and her horde away. He comforts the motherless children and hides them in his voluminous sleeves.

Jizo, whose name in kanji reads "earth womb," is often pictured as a childlike priest with a staff in one hand. Frequently his statue is adorned with numerous layers of bibblike collars in bright colors and many small stones piled up at his feet (and occasionally on his head and shoulders). The bibbs are presented by the devout and by bereaved mothers to cloth the small spirits robbed by the witch. Stones are piled up to help the little ones in their near hopeless task of building a tower to Paradise.

These stone statues are often placed along well-traveled roads and at intersections so passing traffic would aid the penance task of the dead children. The statues themselves are quite varied in style — some are bas-relief on blocks of locally quarried rock, while others are finely detailed pieces carved from soft Oya-ishi. Many of these guardians are housed in small lean-tos and occasionally grouped together with assorted other dieties worshiped in that particular neighborhood.

Friends purchased several "old" Jizo from antique dealers which brought apparent bad luck at the same time. After the statues were returned to a temple and rededicated in a Buddhist ceremony, the misfortune plaguing my friends disappeared, so a word to the wise. Take a photo of one whose style you really like and order one made to match. Better safe than sorry.

FURIN

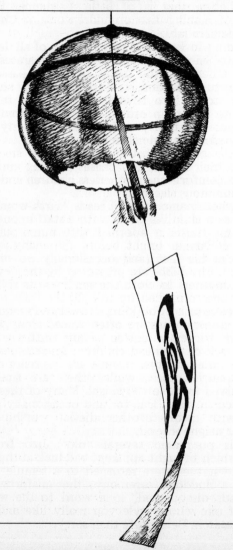

Autumn was nearly over and the wind was really becoming noticeable or I may not have given a second thought to including this mingeihin — wind chimes or FURIN. My own was jangling to and fro and in its frenzy of tingling sounds, the right buzzer sounded in my head to retrieve it for use next year. Surprisingly, the fragile glass ball was none the worse for wear, having weathered the whole summer and much of the autumn outside my window.

I remember when I put it up, there was hardly a whisper of wind and the stifling heat of midsummer evenings often drove me to the rooftop of my Tokyo apartment house. At least there it seemed cooler! My furin, gotten in Asakusa, did little work and only occasionally rang in response to a rising breeze. But one got used to hearing it only occasionally as part of the soundscape that daily passed my windows. Along with mad chirping of flocking sparrows, the cawing of two huge black crows and the raucous caterwauling of local felines — hearing the furin ring so delicately was pure pleasure.

And pleasure pure and simple is essentially why this particular item came to be. It dates to the Edo period when glass blowing was a fledgling art form and the novelty of having something so finely wrought was the height of fashion. The idea of a wind chime was not new in Japan. Indeed they are often mentioned in the "Kojiki" and in classics of the Heian period are several references to their delicate sounds on summer nights.

The open-ended glass globe threaded on a knotted string has a small brass (but occasionally it too is glass) clapper hung from its center. A strip of paper, mostly emblazoned with a poetic thought, gives the clapper enough wind sail to set it ringing when breezes blow. The globe is often simply banded with concentric rings of enamel painted on the inside or with a floral motif that rings the globe's equator and is backed up with a brilliant wash of red. The rough jagged edges are intentionally left so for better sound variations when struck at different points.

Regardless of which type you own, you'll be thought eccentric to say the least if you leave it outside ringing through the winter. Chimes are associated with summer and the coolness of their pealing is but one way in which the Japanese "cooled off" before air-conditioning became de rigueur. So you can see only eccentrics would keep one up in winter!

SHUGI-BUKURO

On November 15th, one of the more colorful and delightful of Japan's many festivals is celebrated nationwide. Shichi-Go-San or the "7-5-3 festival" is when parents of children who are any of these three ages, dress them up and take them to a shrine. In olden days it was girls of three who had their hair done for the first time, boys of five who wore their first pair of hakama (kimono trousers) and girls of seven who wore their first obi (silken cumberbund) but times have changed. Today one sees all children of all three ages dressed in a wide range of clothing styles — everything from a full set of colorful (and expensive) kimono to the latest styles straight from name couturiers of Paris fashion.

All this is leading to SHUGI—BUKURO. On almost any occasion when one gives money for any reason, be it a wedding, funeral, a new baby, New Year's or Shichi-Go-San, the money is presented in envelopes. To do so otherwide is considered crass.

The variety of envelopes is astounding but no doubt the more interesting are the smallest, hand-printed with woodblock designs. These are the type used to give money in very small amounts — more polite than just handing someone a few coins.

The illustrator says that when he was a child in mountainous Hyogo-ken, any time a parcel or furoshiki-wrapped gift was to be delivered to a neighbor, he, his brother and sisters all clamored for the job. Why? Well, when the parcel had been safely seen to its destination, the deliverer would wait for the tray and cloth wrapper to be returned. A polite thank-you later and the young bearer could start home with his task fulfilled and a bit of booty too! Inside the neatly folded furoshiki was always a small envelope like these holding a coin or two which belonged to the delivering party. When you knew you were going to get a five- or 10-yen piece to spend, you certainly were ready to help more willingly.

Each of the envelopes has in one corner either a printed image of a paper-wrapped strip of dried abalone or the stylized hiragana reading noshi, the name of that emblem. From ancient times, the giving of dried abalone (awabi) on felicitous occasions has been practised, and though one now sees real dried awabi noshi used only on the most expensive shugi-bukuro, the custom continues graphically.

KI-USHI

It wasn't so long ago that bullfighting Japanese style was a pastime found throughout the nation. Nowadays one must travel to Shikoku (Uwajima, to be exact), Kyushu (Tokunoshima in Kagoshima-ken) or Okinawa to enjoy this spectactor sport. Without the blood and gore of Spain's man against beast, Japanese bullfighting pits beast against beast in matches very similar to sumo tournaments.

Togyu means fighting bulls and one toy related to this rural event is HATACHIMURA-NO-KI-USHI or wooden bull of Hatachi village, a hamlet in Niigata. They no longer practise bull fighting in this district, but its popularity in times not long past gave birth to this simple toy that carries the traditions of the recent past for future generations to savor.

Togyu events pitted two huge bulls festooned with red, white and black streamers against each other in rings measuring 15 meters across. The two adversaries are manipulated by their trainer-owners and are soon angered enough at one another to begin their push-shove contest.

Overstepping the circular boundary or being overcome physically denotes the loser. Winners are then awarded a flag or drape symbolic of victory. These huge animals are typically quite docile and were regularly used by farming communities for plowing and hauling. It takes quite a lot of cajoling to arouse them enough to fight but when they do battle, it isn't the sharpened horn that is favored but rather brute strength. By agile moves, the bulls try to maneuver into a position that will allow them to shove their opponent from the ring.

Children in their enthusiasm for emulation got their fathers to make miniature wooden bulls for them to play with. Each is cut from a thick tree limb simply sliced to suggest the head. A curved branch fitted into a shallow notch serves as horns and the finished model is festooned with multicolored streamers just like those in life. Children play with these kiushi by dragging them at each other firmly tethered to a length of cord. A circle scratched on the earth serves as their fighting ring.

It was believed that spirits of famed fighting bulls came to inhabit these toys and as such became amulets dedicated to the Gods and displayed on kamidana in rural homes. Toy-amulet-toy: the never ending cycle of mingei.

HATO-BUE

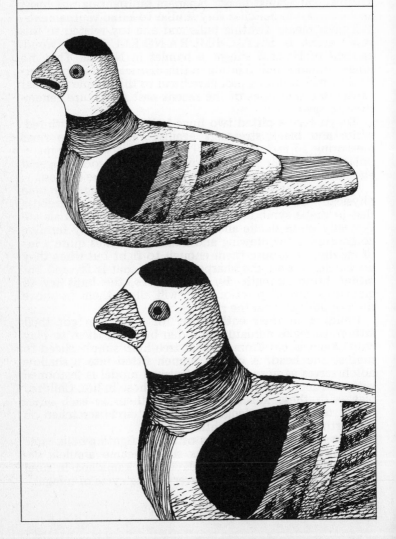

A omori in the far north of Honshu, Japan's main island, is noted for a number of folk crafts not made elsewhere.

The history of HATO-BUE dates to the Edo period when the local daimyo was building a fortified keep. The kiln, made to fire roofing tiles for his castle, was given to the village where it was located when its main job was fulfilled. From tiling to earthenware and whistles! That was the change in use of this sloping kiln's output.

Functional earthenware could almost always find a ready market locally but the whistles were made for quite a different reason. Locals believed that various diseases came from a wide range of outside influences. Hysteria in children was thought to come from an evil spirit that was easily frightened by noise. So, of course, one encouraged children to play noisily and what better noise maker than a brightly colored whistle.

Not all of the many whistles produced by this mingei kiln were pigeon forms but the pigeon has come to be the most widely known. Its attractive shape and multihued coloring made it popular far from Aomori and one can find it for sale throughout the land.

The clay base for these simple tweeters is made in press-moulded fashion. Two halves of a carved mould are filled with a layer of finger pressed clay. Fitted together, they join into a single unit with a hollow center. The mouth piece is found at the tail end while the sounding slit is positioned on the belly to take advantage of a spacious reverberating hollow inside.

Coloring is highly stylized. Who ever saw a purple, pink and green flecked pigeon? But then, why not? The white background sets off the various shades of decorative color used to denote the pigeon's beak, pate, neck-ring, wing and tail feathers. Today's variety comes also in a number of sizes — from ones you can easily cover in your closed fist to those actually bird-sized to a gigantic and mostly decorative piece that one would be hard put to lift to lip, much less get up the breath to blow a piercing note on.

Hato-bue are first-rate remembrances from Aomori-ken and you've a pick of sizes, prices and sounds when you choose this folk art preventative for hysteria in youngsters. Just be sure to pick one whose call doesn't drive you in that direction!

NOBORI-ZARU

Miyazaki, one of Kyushu's seven prefectures, has a long, nearly bayless coast fronting has the Pacific Ocean. With a subtropical climate, it is a popular resort area. Miyazaki gives its prefectural name to the local capital and the shrine located in that city dedicated to the Emperor Jimmu, first of the Yamato dynasty emperors.

Of the engi or luck bringers sold in Miyazaki the NO-BORI-ZARU monkey is typically presented to parents of newly born boys. It is thought to protect them from disease as well as bring them good fortune in their lifetime. Monkeys in Japan are generally thought of as fortunate animals and superstition puts those born in "monkey" years (according to the Chinese zodiac system) as especially fortunate. Believers invariably point to Hideyoshi, the "monkey-faced adventurer" who was born in a monkey year and succeeded in becoming the master of all Japan.

Several of Japan's greatest suiboku arists made the monkey a prime theme for their works, and today nearly everyone knows the famed trio of hear, see and speak no evil that are carved into a transom at Nikko's Toshogu Shrine.

Their association with the God of the roads, Kishin, causes carved replicas of the famed trio to be frequently found along highways and byways. Their meaning is derived from a pun on the word saru (monkey) and zaru (a negative verb ending). Hence mi-zaru, kika-zaru, and iwa-zaru are strangely translated as not-seeing monkey. not-hearing monkey and not-speaking monkey.

Nobori-zaru have a thin pole supporting the banner from which hangs the light-weight papier-mache monkey. The dancing drum tied to his back brings to mind times past when performing monkeys danced to a drum beaten by their owners. The gohei, an angularly cut piece of red and white paper attached to the drum, is representative of cloth offerings given deities in ancient times. The monkey itself wears a red loincloth and helmet, while the banner is decorated with hanashobu, a flowering iris especially connected to Boy's Day festivals.

The idea of the toy is that when wind billows out the banner, the monkey climbs the pole. It is often set where breezes will move it and delight the youngster it was presented to protect and aid. This particular mingei amulet-toy was featured on the New Year's stamp in 1968.

SHIMENAWA

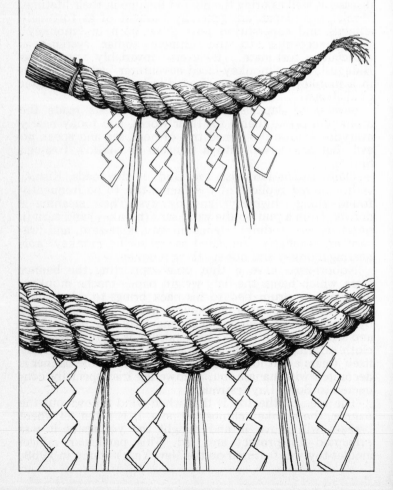

S HIMENAWA or sacred straw ropes can be easily seen throughout the year at shrines.

Shimenawa are always hung before Shinto shrines and around places considered sacred.

According to Shinto beliefs, evil cannot pass beyond a line of shimenawa. Plaited from rice straw in a left-handed twist which represents the positive aspect of nature and existence. Most have decidedly larger ends which taper.

The biggest end should be placed to the left side of the shrine or sacred spot.

The origin of shimenawa dates to the time of the Sun Goddess Amaterasu. It seems that family problems caused the Sun Goddess to hide in a deep cave. She was finally forced from her hiding place and to prevent her returning therein, Prince Futodama placed a rope across the entrance. Called "shirikumi-no-nawa" or the "don't retreat rope," the term was later shortened to shimenawa.

With such an illustrious background, it's no wonder that part of welcoming in the new year involves the making and display of special types of shimenawa for residences. The wanawa or circle ropes used at New Year's are a modernization of traditional shimenawa. They are often displayed unadorned or perhaps with only a few simple white paper gohei and hanging strands of unplaited straw. But those that are added to have a plethora of items attached to the rope backing, each having a special meaning.

The red lobster (ebi) has a name that means sea-old in characters and hence is symbolic of longevity. The sea tangle (kombu) suggests and stands for joy and happiness. The citron (daidai or yuzuriha) homonymously means "from generation to generation" and is thought to ensure the continuance of family. Another type of sea weed (hondawara) represents rice bales (their term, tawara, is similar in sound) and signifies wealth. The piece of bracken (urashiro) has a white backside and therefore stands for honesty and sincerity. Dried persimmons on skewers stand for health and success. Occasionally another plant (tokoro) and a piece of charcoal (sumi) are hung in tandem with the daidai to mean "dwell at one place for generations."

If this year-end decoration isn't hanging on the front entryway, it probably is sitting atop two large cakes of rice paste (kagami-mochi) in the tokonoma.

OMIKI-GUCHI

Nara is surely one of the main, if not the main, centers of Buddhism in Japan. It is here that many of Japan's finest Buddhist images are, and it was from the Nara region that many doctrines on Buddhist theology first made religious inroads centuries ago.

This folk art item has direct connections to the propagation of Buddhism. OMIKI-GUCHI literally translates as sacred wine mouth. A stylized flame that springs from the mouth of a wine vessel, the two parts are important images for Buddhist theology. Fire and water are the methods by which man can purify himself or objects for presentation at a Buddhist altar. And symbolism of these two staples is necessary for establishing an altar anywhere, including in the home. Open flames aren't always the wisest idea and so these finely crafted wooden replicas came into being.

They are still being made by one Nara family — a traditional livelihood passed down generation to generation for 300 years. Sold in boxed pairs, a set is placed on the kamidana (god shelf) or in front of the Butsudan (Buddhist altar) arranged as shown here in a simple vase.

Yoshino hinoki, a variety of particularly fragrant Japanese cypress, is used to create these delicately scented "flames." Only straight grained wood free of knots is used, and only hinoki seems flexible and strong enough to be carefully skived into the thin strips necessary for fitting together in a crosshatch manner.

With the advent of electricity and low-wattage candle lamps, the popularity of omiki-guchi has been on the wane. Still, along with many other true folk arts, they have been given a reprieve of sorts due to publicity in a number of vernacular magazines. Many younger people are being attracted to appreciation of their cultural heritage through mingei and that bodes well for much that seemed doomed until quite recently.

New Year's is always the time of change — one cleans house thoroughly (the Western counterpart of spring cleaning) and making sure the kamidana, where the gods of the house are served, is properly in order might mean getting a set of these special mingei flames for display thereon. This is one more way to start the new year off right in Japan.

HITSUJI-DOREI

E very eighth year of the oriental zodiac is represented by either a sheep or goat and although most images in Japan seem to be sheep, it was probably the goat who held first claim to representative animal amidst the junishi.

Hitsuji is Japanese for sheep while yagi, the term for goat, literally means mountain sheep. The one pictured here is actually a clay bell that clangs more than rings. A round ball of clay jumps about the sounding hollow within the body to make it peal but the sound is far from what one would expect from an ordinary bell.

Clay bells have long been part of Japan's folk art history. Many temples and shrines throughout Japan are noted for the nendo-suzu they sell as charms. Many have highly original patterns, but today, one finds the zodiacal animals a favored theme with all 12 represented quite stylishly.

This particular bell came from Kyoto, and one quite similar is depicted on the New Year 20 yen stamp for 1979. The 1967 stamp featured another sheep carved of wood.

Sheep aren't indigenous to Japan and in fact up until the First World War when supplies of wool were cut off from the main producer, Australia, no one much bothered to raise them. Assorted problems beset sheep farmers in this humid climate — mainly troublesome foot diseases that make profits an almost imaginary goal. Now wool has once more become a staple import with Australia again the major trading partner.

Back to bells, these clay pieces were frequently purchased as charms for the healthy propagation of silkworms. Farmers purchased them in January from nearby temples or shrines to hang near racks of their silkworms. The occasional movement of these bells made their sounding a reminder to the gods of the importance of the hibernating worms to the livelihood of the farmer and his family. Dorei is another term for nendo-suzu or clay bell.

AKEBI-KAGO

Wintery blasts that may be sweeping across mountain and valley in Japan's far northern prefectures (the Tohoku region), mean it is also the time when some craftsmen are busily weaving recently collected akebi vinery into handsome baskets. Autumn is when the dormant vines of this indigenous plant are collected. They are found throughout this island nation, but some areas have been nearly denuded due to overcollecting on the part of makers whose main motives are profit, not craft. The fruit of this small vine is edible and is widely found in vegetable shops even in the largest cities in autumn.

The fall collection of vines ensures the resurgence of life that spring would bring dormant buds along akebi branches is stilled but the softly pliable character of the vine remains intact. The cool, if not cold, weather triggers stoppage of sap flow which, if properly retained, keeps the vine in perfect condition for the simple in and out weaving it is used for in Tohoku.

Today's Tohoku craftsmen make akebi vine baskets in a wide range of styles, not just the typical traditional wares such as have been made for literally hundreds of years for their own use. Those staple baskets like the brushwood backpack totes and large gusa-kote (handled weed carriers) are now joined with an assortment of more "modern" forms. Flat nesting trays, mailbox baskets for hanging outside your entryway, shopping bags that are deeper and stronger than any paper bag ever could be join with a variety of vase baskets including small tubular types (kake-hana-ire) for hanging on the wall.

Warp and weft both are made of vinery with the warp often a slight bit thicker. Ends of the basket are woven back into the finished weave leaving outer edges smooth. It seems that AKEBI-KAGO age better with use. The handle of my own shopping bag has become more pliable with natural oils seeping into it from being carried. Both outer and inner surfaces seem smoother and almost burnished from use, 10 years already and not a break anywhere.

Rustic in appearance because their reddish-toned outer skins remain, these baskets are extremely sturdy and long-lasting examples of mingei artistry. One reason why is that they seem to be non-susceptible to many of the wood-boring and crunching insects that inhabit every nook and cranny of Japan. Although bamboo seems much stronger, it is less hardy due the voracious appetite of a certain bore-fly that soon makes fine sawdust of its inner structure.

DAI-KICHI-GOMA

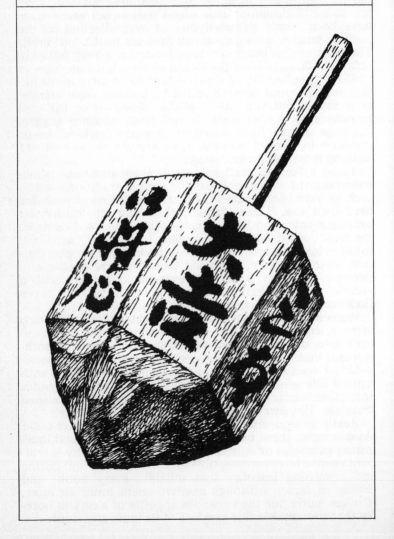

Fortunetelling is a widespread pastime faithfully attended to by many in this land of believers. And there are any number of ways one can divine the fortune fate is sending your way. Most temples have a small cask of joss sticks which you shake and invert to bring one out of the narrow opening. Each stick has a number engraved on it, a number that corresponds to the written fortune the attendant will give you providing you've paid!

That small slip of paper will have all sorts of information on it regarding your health, marriage prospects, the fortunes of your family and a list of auspicious days as well as unlucky days to watch for. Once read, they are generally wrapped about a branch of a nearby tree to serve as a reminder for the gods not to forget about expected good luck or to aid preventing misfortune if that was your lot.

And almost any evening, one can see palmists along busy streets (some with long waiting lines of hopefuls). Their popularity is yet another indication of the widespread belief in fortunetelling.

So it isn't surprising to find that mingei too has a fine old example in fortune-divining devices: a simple six-sided top made of soft paulownia (kiri) and with a handle stem of bamboo. Each of the six sides has one of the following terms inked on: dai-kichi, chu-kichi, sho-kichi (i.e., great, medium or small good fortune) or dai-kyo, chu-kyo, sho-kyo (great, medium or small misfortune). After the top is given a spin, the side facing up is the reading given the spinner. You make your move and take your chance! Mostly this type of top fortunetelling is used to answer specific questions and although it is in toy form, it is a serious riddle-solver for many believers trying to divine the graces of the gods.

DAI-KICHI-GOMA (good fortune tops) hail from Tottori-ken in southern Honshu but are generally not sold in shops. Instead, they are true folk art works fashioned by the people who use them. You probably won't be able to pick one up in a local mingei shop, but then that doesn't mean it isn't a perfect example of an enduring folk art from Japan.

POPPEN

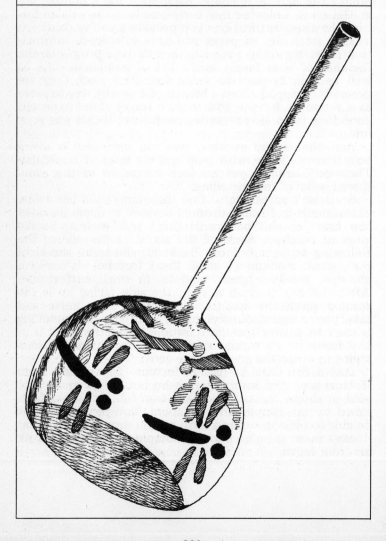

Pop pen, pop pen, pop pen. The equivalent of ping and ting where the sound of glass is concerned here in Japan. These sounds give their name to a delightful toy that one sees far oftener graphically than in truth. This is part of what makes POPPEN one of the folk art traditions of Japan.

Glass was only rudimentarily known to most Japanese prior to its popularization via the Dutch and their Nagasaki bastion of trade. Beads and small vessels were made long before the Dutch ever thought about or much less heard of Japan. But those forms testify to the limited level the art had reached despite the competence of a sister fire art form — ceramics. True glass - blowing arrived with the gaijin and took root like it was native born. Soon one found bottles and the like widely popular and available. It wasn't long before functional objects gave rise to baubles and poppen has to be the ultimate glass bauble. A simple toy that one has probably only seen in old ukiyo-e, this "whistle?" became popular with all the strata of society. The elegantly coifed geisha who plays with one in a memorable old woodblock no doubt points the way toward explaining how poppen became one of the toys of the Edo period. The restricted life of the geisha helped popularize any gewgaw that would amuse them. The delicate glass bubble whose flattened end popped when the tube was blown on lightly is often decorated with painted flowers, scrollwork and/or redbodied dragonflies (akatombo). The thin-walled glass toy never seems to last as long as one wishes, but then too that appealed to the sensibilities of the times when the transitory aspect of life was a romantic notion much favored artistically.

It made its approach to respectability through the fairs that accompany many of the festive religious holidays and found a welcome patronage in the fad-conscious Edo community. Although it is still made in Kyushu where it first appeared, it is also well known in both Himeji, the town surrounding the ever magnificent "egret castle" and in modern Edo, today's Tokyo.

Wherever one comes across this unusual toy, it is hard not to give it a test puff just to hear it pop pen! But handle with care or it too will be part of the folk art past.

KUMI-HIMO

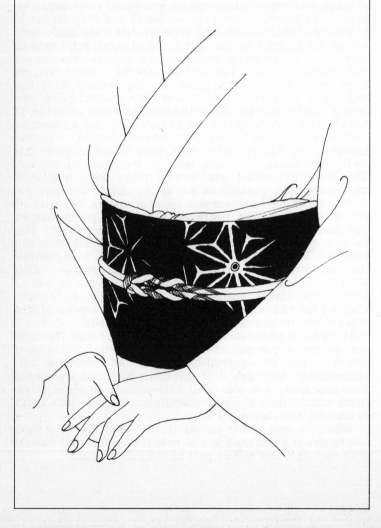

There's usually so much interest in the pattern of a lovely kimono that people miss many of the finely detailed assortment of parts that help to make the whole picture so fetching. The simple kimono is far from being so simple as it may appear. And one of the last vital accessories to be put on when wearing kimono is a specially woven silken cord called called KUMI-HIMO or obi-jime.

Woven cords have long been part of the cultural history of this land and although some feel the art to be indigenous, others lean to its being an art form borrowed from neighboring China. Whatever the origins, the making of kumi-himo has evolved into a highly specialized art that is widely practiced and admired throughout Japan. No one area can lay a special claim to fame based on kumi-himo. Instead, one finds assorted patterns being typical from certain regions, although this is becoming less true with the passage of time. Still, the most renowned maker of kumi-himo is probably a Tokyo-based concern begun in the mid-1600s by a samurai family to produce cords for armor and weaponry in that era of feudalism.

The shop smoothly turned to the production of obi-jime when the Meiji Restoration brought an abrupt halt to the need for armor cordage. Following the end of the Pacific War, this concern was asked to study ancient cords kept in various Imperial repositories and temples in order to reproduce their intricate patterns. A 10-year program of intense research led to the designation of this firm's work as an "intangible cultural property." They now have a repertoire of well over 400 ancient designs, the simplest of which uses but four spools, while the most expensive boasts a total of 97 spools and requires eight people working in tandem to produce but three cm per day!

Kumi-himo directly means plaited cord, while the second more definitive term, obi-jime, means sash belt. Anyone who's ever seen the heavy brocade that obi (sashes) are made of can easily imagine why a supple but strong silken cord is used to keep it both tight and in place.

One other addition to the obi-jime may be a clasp or obi-dome, the equivalent of a broach, to join the cord, but most young Japanese favor simple or double knotting like the illustration shows. Overall patterns or partial designs in colors contrasting with that of the obi are but one more elegant bit of artistry that help to make kimono and the wearing of these graceful apparel a truly Japanese idiom.

HEBI-BUE

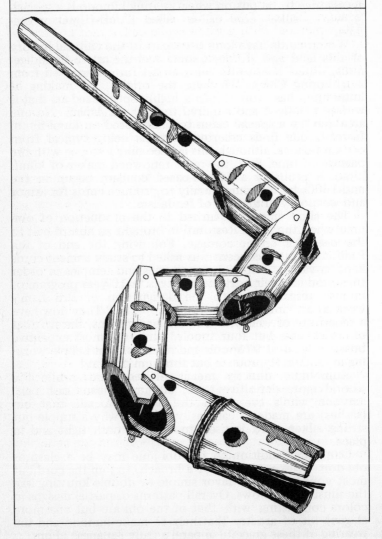

E very sixth year of the oriental zodiac is represented by the snake. Following on the heels (if they have feet, they must have heels!) of the dragon, snakes are typically portrayed as the harmless sort: no lashing tongues or triangular heads. In fact, the snake in Japan is most closely associated with the goddess of love and beauty: Benten. One of the seven "lucky" gods, she is often pictured with a white snake coiled near her feet or around the rock on which she sits, an association dating to the importation of this goddess from India via China and firmly established with all sort of "native" legends concerning her beneficient character and lithe messenger, the snake.

Japan has a number of types of snakes, including several extremely poisonous varieties -- mamushi found widely on the four main islands and the related family of yabu (vipers) found on Okinawa and those small southern islands.

It's only proper then to expect the Japanese to become snake fanciers in many ways, including their supposedly superior medicinal values. Although such popularity has decreased, it wasn't long ago that over 5 million scaled creatures found their way into the digestive systems of the Japanese each calendar year.

It is equally interesting to note that many words use a Japanese term for snake. Janome, the delicate oiled paper umbrellas are literally "snake eyes," while jamisen, indigenous musical instruments using snake skin coverings give the snake literary credit too!

A whistle of painted and jointed bamboo sections that resembles a snake is a favored plaything throughout Japan, but is one of the few folk art toys modern Tokyo can boast of. Widely sold at fairs around the city, it was the New Year's subject for the 20-yen stamp issued in 1977. The jointed body sways to and fro, while the three notes are being piped. Hopefully being piped not too loudly that is.

That this mingeihin is made of bamboo attests to bamboo's versatility and availability, even in the sprawling metropolis of modern day Edo.

OKINASAN

OKINASAN, a papier-mache tumbler doll from Ishikawa Prefecture, could easily be passed off as a variant daruma but hopefully this column will set the record straight. Its origins aren't datewise reliable but legend says the first such engi doll was made by a pious old man who worshipped the Japanese god of war, Hachiman.

Hachiman was originally the Emperor Ohjin, whose deification into the Mars of Japan came about via devotion to his shrine by the Minamoto clan. He is believed to have been wrapped in red swaddling at the time of his birth and so the doll emulates not the red dhoti of the itinerant Indian priest but this god's baby wear!

The full name accorded this doll is Kaga Hachiman Okiagari, from the old region name, the shrine/god name and a combination term literally meaning get up. The weighted base of this rather light toy always brings it back to a standing position regardless of how many times it falls. Naturally it's a reminder to never give up if you're to succeed in making your way. A Japanese toy version of try, try again.

As an engi toy, Okinasan (the locals prefer this short-ened name) fills many roles. Those who keep theirs in a tansu will supposedly be blessed with an abundance of clothing materials.

Newly married couples receiving one are assured of raising healthy children, while a sick person getting one is aided in shedding his illness or impurity. The goodluck symbolism of sho-chiku-bai (the painted branches of pine, bamboo and plum) is likewise helpful and, although a recent addition to the overall design, made it more saleable at the first market of the new year. This change and the improvement of many Kaga (Ishikawa) crafts were due to the keen support afforded local artisans by the ruling daimyo family. Both the third and fifth Daimyo actively sought higher standards of craft from their province and even brought experienced craftsman-teachers from as far away as Edo and Kyoto to improve traditional arts.

As opposed to the Shinto rendering of the meaning of Hachiman, Buddhist doctrine claims it means the eight right ways: right seeing, hearing, thinking, talking, doing, living, walking and enlightenment. Deviation from this path is only human, but as Okinasan always comes back to an upright position so the true way will be the believers path. With all these "helpful" aspects it seems one shouldn't be without two or three in his possession.

ORIGAMI

ORIGAMI, literally folded paper in Japanese, is an art that appeals to all classes and ages. And one frequently sees people of all ages almost absent-mindedly fashioning exquisite miniatures from odd pieces of paper left lying about.

Origami has its origins in the rituals of Shinto and Buddhist services. Although most people don't associate them with the more amusing side of this paper folk art, the white folded strips called nigite are simple origami having an ages-old religious significance. Meaning clasped hands, they represent the encompassing hands of the gods to whom all supplication is directed. They are most often found at holy spots, along with a supporting rope of rice straw (a shimenawa).

Early origami made it possible to represent various life forms beautifully and inexpensively for ritualistic religious purposes, but the art soon found favor as a means of amusement, especially among, the entertainment world. It was slightly demanding to master but took little space and was truly inexpensive. Add those aspects to the fragility of the finished work and one begins to understand the fascination of origami.

Today, in addition to the many "typical" origami that most people try their hand at early in life there are a growing number of specialized designs. These new forms are variations that make frequent use of more complex folding and even bending or curving of the straightly folded paper seams. Agile fingers and a full set of fresh wits about you are imperative to creating at this end of the origami scale.

Origami paper is usually square, and the color or pattern chosen often reflects the character of the object fashioned. But then you come across the facile artist who can turn anything into origami and ends up with a flock of tiny cranes, each balanced at the end of a tightly rolled paper sleeve from a set of chopsticks. Such a flock is amongst my most favored pieces of folk art and has a place of honor high away from the reaches of inquisitive cats.

One truthfully needs only a sharp eye to follow drawn instructions in most any Japanese book on the subject. But beware for you'll soon find yourself under the spell of folded paper, a pastime that seems to grow more pleasing with every new form mastered. * Senbazuru," strings of 1,000 origami cranes are shown on page 133.

UZURA-GURUMA

A related toy to this piece is Kumamoto's kiji—guruma with a history intertwined with the Heike defeat at Dannoura. Similarly but not exactly, this chubby wheeled bird supposedly represents the uzura or quail and is termed an UZURA—GURUMA. It hails from Miyazaki-ken in Kyushu.

Strangely enough, almost every simply carved, wheeled folk toy comes from Kyushu and historians today attribute that to the close ties Kyushu shared to neighboring China and the traditional toys of that nation's heritage. The pictured bird is the male version. The female is both larger and less brightly plumed even if her feathers are but simple strokes of color in emulation of plumage.

The quail's legend connected to Japan's first emperor, Jimmu, but these small uzura-guruma have a lengthy history of their own. One of the best bets concerning the origins of this toy has to do with the Korean influence that reached Kyushu via an influx of refugees following the Silla defeat of the Paikche Kingdom. The Paikche had been allies of the Japanese and it was only natural that many fled to friendly territory following dissolution of their nation. It is thought that through this influx of talent, the greater portion of "borrowed" cultural achievements reached Japan. The arts of sericulture, weaving, metal-casting and brewing as well as writing and literature are thought to have been firmly grounded during this period about the mid-seventh century.

Despite its historical imperial lineage, the first uzura-guruma is thought to have been fashioned by a Korean immigrant who, on reaching his 100th birthday, made the toy to be given to his descendants. It soon came to have added meaning and was thought to be especially helpful to women during childbirth. Even now it is bought for that purpose by Kyushuites. The only question that brings up is why then are there two sexes? Well, as with so many truly old folk toys, the truth can only be conjectured at this far into the future from their conception. But it is nice to know that many are older than tourism and continue almost unchanged physically for other generations to take pleasure in.

TAKE-TOMBO

Leonardo da Vinci was enamored of the idea, as have been countless others from many nations and eras, so it stands to reason that Japan too should have a helicopter. It may not be as complex a construction as da Vinci's Rennaisance model, but TAKE-TOMBO delights all ages when it soars aloft.

This lightweight toy hasn't any particular historical background that can be retold in anecdotal form but hardly a country-bred child didn't own one in their youth, perhaps one they even fashioned themselves. Its skived bamboo (take) propeller is plugged onto a thin post. Nowadays, the commercial variety that you can easily find wherever omiyage are sold uses a dab of glue to bind post and propeller together. My background informant assures me that instead of glue or a tight fit, a notched sleeve arrangement was favored in his mountain village. The fit had to be just so, and many hours were spent in making it thus. Peer pressure and all, no one wanted to have a toy that wasn't exactly like the other kids even if you had to make your own.

Take-tombo are sent whirring by rubbing the stem post between the flats of your closed palms. One good rubbing motion, open your hands and off it goes. A great toy for out-of-doors, I guarantee you it's not meant for indoors. Besides my cats attacking it in flight, it whirled into a small plate and chipped a piece out. An affixed stem seems to act like a balance to the twirling blades, but the variety that the youngsters used to (still do?) make with a notched sleeve has an erratic and longer flight pattern. The twist that sends the propeller aloft leaves the launching post in your palm while you need a quick eye and fast feet to keep up with these mingei helicopters.

The name means bamboo dragonfly because the whirling blades no doubt resemble most the flashing wings of those amazing insects. Did you know that dragonflies can hover in one spot too? And when you learn the knack of sending your take-tombo into the air, you naturally try to get it to hover as a demonstration of your prowess at the game. But the fun isn't in whether yours can or can't hover, but just in seeing it spring to life with a whirring buzzzzzz....

TENJIN-SAMA

Wherever you travel throughout the many islands of Japan, you're sure to meet TENJIN-SAMA, the patron god of learning and literary arts in a form similar to the one shown here. Over 100 varieties of this popular deity are made in the 47 prefectures. Some are carved of soft wood (aburanko), others use a mixture of sawdust and glue, while some (mainly from the Tohoku region) are made of papier-mache. But it seems that the most popular and well-known are tsuchi-ningyo (clay dolls) made by forcing pliable clay into a two-part mold, pressing the halves together and baking the formed piece before painting them with an array of brilliant hues.

Tenjin, by the way, is but another name for Sugawara Michizane, the Heian scholar exiled to Kyushu as a result of political intrigues at the Kyoto court. His new name was a result of deification and enshrinement at Dazaifu Tenmangu in Fukuoka-ken. Replicas of this famed researcher of Chinese literature include a plum blossom pattern. This floral design on the robes of the courtly figurine reminds one of the story about Michizane's original exile. He had always favored the ume (plum) blossom and when he was demoted to position of Vice Governor-General of Kyushu, his favorite plum tree in his Kyoto mansion garden uprooted itself and flew through the air to Dazaifu, too! It got the name tobi-ume for that feat, and a plum tree in front of the shrine oratory is said to be a descendant of the original "flying plum." The flower thus became firmly connected to the ideals that Michizane stood for, and so grace his costume.

Most Tenjin statuettes show the revered Michizane seated on a dais with a folded fan in one hand and a woven horse-hair cap (e-boshi) on his head. A regal emissary fit to be symbolic of educational pursuits and very much honored all over Japan.

Occasionally one finds standing figures of Tenjin-sama but they tend to be short in stature, almost as if his position wasn't stock upright but kneeling. Along with the Dazaifu ki-uso, Michizane's character and studious pursuits are well remembered, and both make meaningful gifts to those embarking on a new course of studies at any educational level.

MI

R ice is certainly the most important grain crop in all Japan and besides its primary importance as a foodstuff, rice straw byproducts are found in nearly every home in one form or another. Given the wide range that rice and the many supplemental related items made from straw rice, it isn't surprising to find a number of Japan's finest folk art objects are derived from association with this agricultural phenomenon.

Winnowing baskets are perhaps one of the most attractive forms of traditional basketry associated with rice culture, although they are by no means exclusively used only for rice grain winnowing.

An explanation of what winnowing is will help understand the design of this basket. Ripened grain has to be hulled and then the hulls separated from the cereal. Hulling is accomplished by treading on dry grain heads that have been harvested. Then the loosened chaff (hulls) and cereal together are placed in the cup of these winnowing baskets. With sure flicking motions up and down, wind does the trick by blowing the lightweight chaff away from the grain kernels, which fall heavily back into the basket's cup. It's a two-handed operation at least and anyone who has done it will agree that easier jobs exist.

This age-old method of winnowing is found throughout the world, and indeed baskets developed for winnowing are all rather similar. It could be that the first designs for these baskets arrived in the East as part and parcel of grain-oriented argricultural techniques originating in the Tigris and Euphrates river basins before written records were kept. Nowadays, one finds winnows of extremely similar nature throughout Asia, the Korean Peninsula and from north to south over the Japanese archipelago.

Japanese Mi or winnows tend to be made of light but durable split bamboo, occasionally interwoven with cherry bark strips and almost invariably bound with either fuji (wisteria) or akebi vine lacings. These mingei are products of function and although they have an established form, their differences from area to area are remarkable in their diversity. One is constantly seeing new patterns and combinations as one travels the rural backroads, but inroads of mechanized farming may well be spelling the doom of these age-old farming tools. Hand labor is quickly becoming a thing of the past and winnowing is more and more accomplished by centrifugal motor apparatii that are far more efficient and labor economical.

UNDO-NINGYO

This motion toy has its origins in the early part of the Meiji era. UNDO-NINGYO literally translates as moving doll. A simple wire-held counterbalance is the source of movement once the doll is given a nudge. Pinpoint feet support the clay doll on its perch and allow it to move in a set arc pattern gauged by the slowly decelerating pendulum's sway.

Today there are three varieties of this doll. Besides the one pictured here there is a genkotsu-ame-uri (candy seller) and a lappa-fuki-heitai (army trumpeter).

Neighborhood candymen were always popular and since children were well acquainted with these itinerant sweets salesmen, it was only natural that one was fashioned into this type toy.

As for why the army trumpeter made an appearance as an undo-ningyo? The victory of Japan over the Chinese in a quickly consummated war (1894-5) over hegemony in Korea led to popularization of the army trumpeter and so his appearance in a uniform of that conflict.

"Hera, Hera Hei Odori" is the title of a popular Meiji era song (Meiji 13) and the dance that went with it gave rise to fashioning of the illustrated doll. Its name uses the dance titling but the bandana-hatted, fan-waving, kimono-clad man is surely mouthing just that catch phrase as he sways to and fro on his precarious perch.

All three of these dolls are made of clay painted with appropriate clothing. Their simple construction in no way detracts from their childish appeal, and despite a period of time when production was discontinued, their reappearance and renewed popularity has put them in the forefront of Japan's mingei toys. They are a speciality of Takamatsu-shi in Kagawa-ken on Shikoku.

TOBE-KAERU

Tilling my small country garden, I was surprised by an early green frog who suddenly jumped from a clump of weed. Its bright and shiny green brought to mind a rather modern haiku by Ryunosuke Akutagawa (1892-1927) for whom the literary prize is named:

Green frog,
have you also had your body
freshly painted?

And then I remembered the many frogs that crop up in folk art throughout Japan. Perhaps the best known are the pairs of usually tiny porcelain frogs one sees and buys at Futamigaura where a pair of huge offshore rocks are tied together with a massive shimenawa. This stop for pilgrims on their way to the Grand Ise Shrines became popular for both the "man and wife" rocks seaside and the frog reminders. Japanese for frog is "kaeru" which is a homonym for the verb to return. Purchase of a pair was surposed to ensure a safe return to wherever. Why frogs at Futamigaura is also surely due their connection to rain. The Keshitama Shrine at Futami is the acclained abode of the god who controls rainfall.

Another famous spot for frogs is not far away in Nagoya. One district of Nagoya proper is called Tobe, but Tobe kaeru are well known for a far different reason. Not too long ago, it was legal for any samurai to practice swordsmanship on just about anybody he pleased. These sword-happy warriors(?) were much feared, and people usually jumped whenever one came around. Well another play on words gave double meaning to the district name which sounds like a form of the verb "tobu" which means jump. So what other jumping animal would one pick to represent this serious reminder to be careful and quick around any samurai in the area? A sarcastic reminder of a not so humorous regularity before the Meiji reforms were instituted.

Usually Tobe Kaeru are made in pairs, either copulating or grappling in what seems to be a male superiority pre-mating battle. Their true-to-life realism brought to mind yet another haiku by the Upasaka Shiki (1867-1902), who penned:

Ways of the world,
may he never know them,
the toad.

Amen to that, but what a springtime paddyside chorus they make!

KOI-NOBORI

The fifth day of the fifth month every year is popularly called "Boys' Festival" and, like the festival set aside for girls on March 3, is symbolized by assorted boy-oriented paraphernalia. Officially a national holiday named Kodomo-no-hi or Children's Day, it is supposedly a celebration for both sexes, but the emphasis is definitely on boys nonetheless.

Formerly the day had several names including Tango-no-sekku or Horse Festival. Horses implied manliness, bravery and strength — all desirable traits for boys to acquire, and so horses and horse riding equipment are often specially displayed on this day. Another name was Shobu-no-sekku or Iris Festival, taking its name from the custom of steeping these sword-leaved plants in the bath water to instill a warrior spirit in those bathing in the infusion. Deep in Hyogo Prefecture, shobu roots were pulled up and carefully fashioned into a green crown with two protruding rhizomes resembling cow horns. Boys were given these natural toys on this day in hopes they would gain the strength of oxen by wearing and playing with them.

Probably the best known boys' festival image is the gaily colored flying carp pennants that wave from tall poles throughout the land for several weeks prior to and after May 5. Like airport wind socks, these carp catch the breezes and "swim" the air currents bravely. One for each son used to be the maxim, but nowadays it's two or three, regardless of how many or few sons, while some families have whole schools of carp aflutter in their yards.

Why the carp is an easy question to answer. This variety of fish is respected for the power it needs to fight its way upstream. Its determination to overcome obstacles is thought to be a fitting example for growing boys to emulate, and so KOI-NOBORI (flying carp) make their yearly appearance atop streamer festooned poles every spring.

These carp pennants are now widely sold, but most are commercially made of printed cotton or nylon. Handmade ones of paper have almost completely disappeared but one can still find hand-painted dyed cotton carp of varied sizes and colors in some of the more rural areas of Japan. See related photos on page 126.

If ever, you see these fish swimming the springtime air waves, while touring picturesque back roads in Japan, it will surely be a sight that long remains in mind.

MIHARU-GOMA

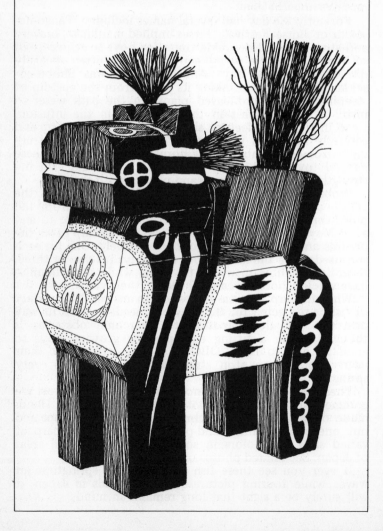

One must recall events of the late eighth century to know the history behind this famous horse toy from present-day Fukushima Prefecture. Miharu Castle was being regularly attacked by Tohoku's original inhabitants, the Ainu, and the emperor at the Heian court ordered renowned general Sakanoue-no-Tamuramaru to lead an expedition against them.

Before leaving Heiankyo (the ancient name for what is now Kyoto), the general went to pray at Kiyomizu on the outskirts of the city. There he met the priest/founder of the temple, Enchin, who was then carving a huge wooden image of the Lord Buddha. With a chunk of wood leftover from his statue carving, Enchin made 100 saddlehorses as a parting gift for the general, who packed them into one of his armor cases.

Arriving at their faraway destination quite exhausted, the battle fought against the Ainu, under their chieftain Otakimaru, was going badly for the Imperial forces until the sudden appearance of 100 horses which effectively turned the tide of war.

After the battle was won, all but one horse, which was wounded, disappeared. But the empty armor case left no one guessing where they had come from.

A villager from the vicinity of Miharu Castle made an additional 99 copies in hopes of leaving the "100 horses" to posterity, but three years later, the wounded horse too disappeared, or so the legend goes. The remaining 99 were then passed down from generation to generation in that family until some of his descendants began making replicas for the children of their village. It soon came to be sold at the local shrine as a talisman to effect the healthy growth of children.

MIHARU-GOMA or Miharu chargers are one of three famed horse toys in Japan, the other two being Yawata-uma of Aomori-ken and Kikyoroshi-uma of Miyagi-ken. Simply fashioned and with equally simple painted styling, these chargers carry an amazing tale to future generations about events from centuries long past.

USAGI-GURUMA

J apanese belief in the power of the zodiac is phenomenal. Some people even today make every decision based on what their fortuneteller dictates and he or she generally bases predictions on the junishi, or 12 animals of the Chinese zodiac, along with other pertinent information gleaned from palmistry and time of birth.

East and west have a common meeting point in the zodiac, as each of the 12 junishi symbols has an equal counterpoint in the Western version, oriented along lunar lines. Thus rat (nezumi) matches ram (aries); the ox (ushi) the bull (taurus); the tiger (tora) compares with the twins (Gemini) and the hare (usagi) is equal to the crab (cancer). You can easily work it out from there.

The usagi or U is connected mythologically with the moon in Japanese lore. This no doubt because Sanskrit for moon literally means "one who carries the hare" and the idea arrived via China along with so many other popular myths. In fact this association of hare and moon is mentioned as far back as the "Kojiki" (circa 712 A.D.) which contains the earliest written record of the nation.

The hare is typically represented as pounding mochi with a mortar and pestle. There is even a day of the hare whereon a sort of "Christmas" tree decorated with pounded rice cakes is displayed in early January.

People born in the year of the hare are thought to be gifted with a facile tongue (flatterers if you will). They are also thought to be very amiable and popular with others. Their "bad" attributes include being proud, often spoiled and apt to quarrel easily with superiors over trivial matters.

Of course, their color is white and the majority of the rabbits depicted in mingei art works are likewise blemish free. The only really funny aspect to being born under the sign of the hare is that numerology gives this prolific species the privilege of having one for their own special number. Brings to mind the miles and miles of antirabbit fencing in Australia made useless by one expectant little bunny!

One of the few wheeled mingei toys made in Japan, USAGI-GURUMA, originated about the time of the Meiji Restoration at Hamamatsu in Shizuoka Prefecture. It was first fashioned of waste calligraphy paper by a frugal former samurai whose original designs are still passed down through his surviving family.

INARI-SAMA

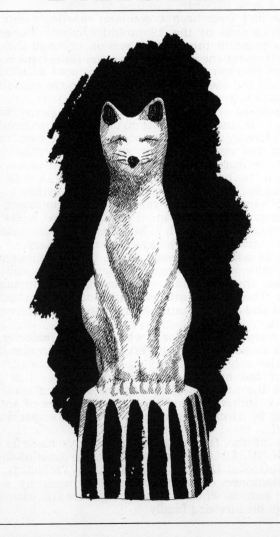

Almost without exception, whenever you pass by a Shinto shrine, the gateway is guarded by a pair of foxes on pedestals. Such shrines are called Inari-jinja and are dedicated to the spirit of the goddess of rice, Princess Utagama, whose messenger is thought to be the fox.

The first shrine in honor of this beneficent goddess was created in 711 by the Hata clan in Kyoto's Fushimi district. The prosperous family wished to thank the goddess for her abundant favor, which had made them large land holders with many paddies and storehouses of baled rice.

Origin of the term Inari itself is disputed, with some believing it to have derived from a chance meeting the Buddhist Saint Kobo Daishi had in Kyoto in the ninth century. He happened on an old man laden with sheaves of ripened rice and carrying a sickle who, when questioned, replied he was the deity of the Inari shrine at Fushimi. Those favoring this story say Inari originated out of the characters for "rice-plant-bearer." The second group favors Inari as meaning "rice-growth," as it is thought rice first grew within the stomach of the goddess Utagama.

Foxes came to be associated with this shrine also in the ninth century when a pair, a white male and a brown female, made their den near the original Fushimi Shrine. These two came to be regarded as guardian-messengers of the goddess herself and so today one finds pairs of fox statuettes throughout the land at every Inari-jinja. Such works are mostly stone but occasionally you find lovely old wooden pieces and even dramatic large enameled porcelain pairs. If the shrine is very small, these fox guardians may well be small too. They are often made of plaster or papier-mache, although porcelain too is popular. A number of fine mingei varieties are made and widely distributed such as this one from Aichi-ken.

Although not all Inari kitsune (foxes) are the same, many pairs are made with the male holding a key in his mouth to symbolize the granary wherein rice is stored while his mate typically holds a hoshu-no-tama (treasure ball) beneath her paw to stand for the source of all good, the deity of rice. Either way, with or without regalia, INARI-SAMA are surely part of a folk art culture that is truly Japanese.

KIBIGARA-NEZUMI

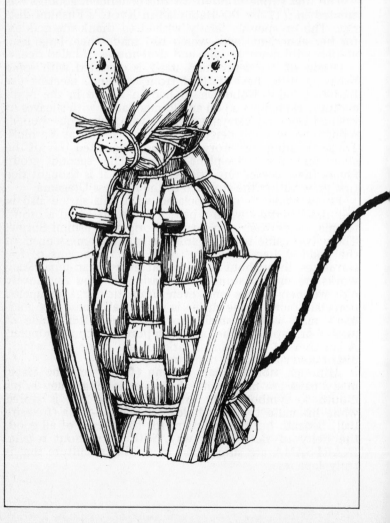

The cyclic junishi begins with the year of the rat or ne (short for nezumi), despite its universal image as a pest. My country house has a thick mantle of straw for a roof and although cool in summer and not too cold in winter, I could do without it being home for god alone knows how many rats. Neither of my cats seems to know rats are their sworn mortal enemies, and the only sign of a rafter snake is the occasional skin one may shed. Still I suppose one should honor these zodiac symbols to some extent but chewed bedding and ravaged tansu make it difficult.

It was once believed that a copy of a cat picture by Manjiro Nitta, a descendant of a famed 14th century general, would keep rats at a distance and many were the homes where such paintings were hung. Another cat-rat story centers on the carving of a sleeping cat above one transom at the Toshogu Shrine complex in Nikko. Carved by Jingoro Hidari, this cat too is thought to keep rats away from the premises, built in the early part of the Edo Period to entomb founders of the Tokugawa Shogunate.

But rats themselves are often depicted in Japanese art. Their association with the god of wealth, Daikoku, often shows them gnawing at either or both of the rice bales upon which this god is ensconced. These two bales are the symbolic prosperity of the country and of individuals. Rats chewing into such riches suggest one should carefully protect wealth. Daikoku's festival day is likewise held on the day of the rat.

Mingei collectors have a wealth of varieties to choose from including a number of plaster, papier-mache and clay works appropriately painted. But the one pictured is unusual in that it's made from kibigara or the stems of millet, a grain relative of field corn and more popularly used for making the brooms Tochigi-ken is also known for. In fact the same general methods of binding these stems into brooms are used to skillfully cord-wrap shapes not unlike all 12 animals of the Chinese zodiac. A new addition to the mingei pantheon, KIBIGARA-NEZUMI made its debut in the 1960's, using broom-braiding techniques practiced since the Edo era.

TATSU-GURUMA

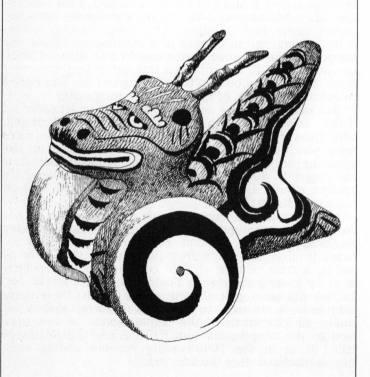

Probably the most maligned and fabulous of the junishi is the dragon. In Japan it is usually referred to as tatsu but sometimes also as ryu. As far as I can find out none have ever lived in Japan, being but another import from neighboring China where they are thought to have been earlier borrowed from Indian mythology. A fiercesome countenance is backed up by two straight antlers and a scaly snake-like body bristing with dorsal fins. It invariably has long sharp claws and often displays flames shooting from shoulders and hips. An early description said it was essentially a serpent with "the horns of a deer, the head of a horse, eyes like the devil, a snake-like neck and a belly like that a red worm. It has scales like a carp, ears like a cow, paws like a tiger and the claws of an eagle."

In Japanese art, the dragon is usually depicted clutching a ball which symbolizes the "gem of omnipotence." Ryu are also limited in skin coloring and are either red, white, black, green or yellow. Different attributes are given each color species thus a white dragon's breath turns to gold, while the spittle of a red dragon turns into crystal balls.

One often runs across dragon motifs like the dragon head from which temple bells are suspended, a ryuzu in Japanese. Formerly the emperor's clothing were referred to as "dragon robes," while his throne is called the "dragon throne." The majesty of this fabulous creature no doubt made it a natural for imperial usage and so one finds ryu-tai meaning imperial person and ryu-ga an imperial carriage. And how about tatsumaki or the dreaded waterspout? Yet one more dragon word in the average person's vocabulary.

Many imperial terms have fallen into disuse, but then one hardly sees a dragon from one dragon year (the fifth of every 12 in the cycle) to the next a dozen years hence. But when those years come into vogue, one is surprised by the number and variety of mingei dragons that surface. A good example is this wheeled, antlered, papier-mache version from Fukushima Prefecture, one of a type of toy called Miharu-hariko. Wheeled toys are not all that common and this rather stately dragon is surely a fitting example of the heavenly sign that stands for respect, uprightness and high spirits. Negative aspects of people born under the dragon sign include impatience and a tendency to be outspoken.

INOSHISHI-DOREI

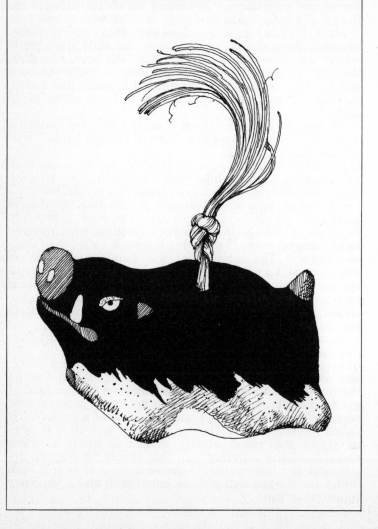

The tail end of the junishi (zodiacal cycle) is inoshishi , wild boar. People born under this sign are considered upright and high-spirited with strong characters centered on pursuit of their ambitions. Short-tempers and impatience may cause them to be disliked by others and they often find themselves to be "jacks of all trades and master of none" when final tabulations are in.

The boar is the symbol of reckless courage here in Japan and people formerly made a special point of honoring this animal with celebrations on the day of the boar each October. Special mochi (pounded glutinous rice) were dedicated at the family god shelf. People afterward ate these rice cakes during the hour of the boar (10 pm to midnight) to be free of disease. Prayers by women to this symbolic animal often were that they would have many children and that all would possess the reckless courage of the inoshishi.

Just to give you an idea of how big and ornery they are, it was common in the Tohoku district to refer to them as yamakujira or mountain whales not too long ago.

Two famous stories are told about inoshishi, one being the heroic feat of Nitan in subduing and killing a wild boar after tackling it from his horse and riding it bareback BACKWARDS! The second is a short scene from the story of the 47 samurai as told in the Chushingura.

A synopsis of what happens in act five is basically, the father of Okaru, Yoichibei, has finally been persuaded to sell his daughter to raise money for Kampei, her lover. Returning home late he is accosted and slain by Sadakuro who has turned highwayman to make a living. As Sadakuro starts off with a wallet full of stolen gold, he is startled by a wounded boar and a few seconds later dies wordlessly as two shots from the gun of the hunter (Kampei) "rip through his body, from his spine to his ribs."

The hunter, thinking he has at last killed his quarry, rushes up to find a dead man and a full pouch of gold. Not knowing who he has killed or that Yoichibei also lies nearby, he takes the gold as a gift from heaven and rushes off. Heavy stuff for any actor to perform for sure but no doubt one of the more famed literary accounts featuring an inoshishi.

The small painted clay bell in boar form shown here comes from Tochigi Prefecture, where similar style bells featuring all 12 junishi animals are produced.

SASHIKO

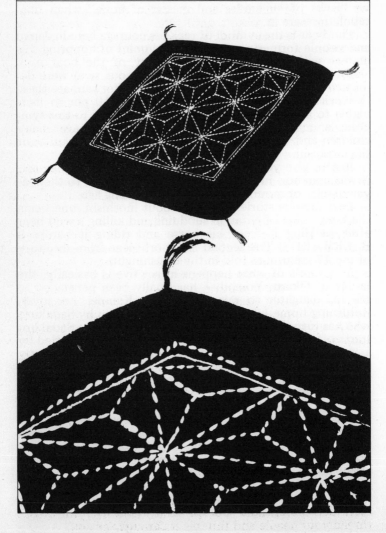

SASHIKO is a very old type of decorative sewing widely found in Japan. Tohoku and seaside regions facing the Japan Sea are rife with all sorts of sashiko embellished goods.

To know a little about this stitchery art form, one should know that once silk was more common than cotton or linen. The manufacture of cotton goods was slow to catch on and it wasn't until after the Meiji Restoration that they became widely used through the improved marketing and mass-production looming of yard goods. Before that time, people who had cotton goods (or linen) were careful to protect them from excess wear and one way the thrifty peasants found was via sashiko stitching.

Worn spots seem to have been the first to get this decorative treatment but soon the advantages of sewing long threads into a piece of cloth became common knowledge and the lovely patterns we so enjoy to see today were born. Darning gave way to making a valued piece of cloth both stronger and warmer with quilting a natural extension in creating complex designs that have their base in plain geometric figures intertwined and interlocked time and again.

There were any number of heavy wear goods that received this, special treatment. Arm and leg protectors that farmers and fisherfolk alike favored were often very originally decorated with contrasting thread patterns. Short under-kimono were likewise quilted and "sashikoed" to make the wearer warmer regardless of the weather. And today one easily sees young kendo enthusiasts trudging home after practice, decked out in dark blue hakama with white upper garments fully emblazoned with intricate loop-on-loop patterns in sashiko.

It seems that anyone and everyone did and does the sewing for this folk art form. There is no feeling of its being women's work and men are just as apt to be engrossed in carefully creating a repetitive pattern in white thread on a dark base material as are their wives or daughters.

The illustration shows zabuton, pillows for sitting on when resting in a tatami room. Today, with less and less true-need for sashiko repair, strengthening or quilting, the art is being used as a purely decorative feature in many items like noren, furoshiki (where it is more true to form as a strength adder) and even in tablecloths, runners and placemats. It is an art that anyone can do and they even sell prechalked cotton that does everything but thread your needle and thimble it through for you.

TANEKASHI-SAMA

T ANEKASHI-SAMA, the seed-loaning doll of Osaka's Sumiyoshi Taisha, is an example of mingei made in the Fushimi clay doll tradition. History dates back nearly 300 years to their origin in the Fushimi district of Kyoto by a small group of potters. Rustic edges were refined and by the mid-19th century, well over 3,000 themes were made throughout Japan using the Fushimi tradition. Today that number has dwindled to 500 or 600, with fewer and fewer left each year.

The "seed-lender" doll of Sumiyoshi is appropriate for this complex, where a small shrine is dedicated to the god of agriculture. Long before Osaka became the concrete jungle it is today, local farmers often visited this tiny sanctuary to honor their patron god and buy this small talisman to place on their home kami-dana or god shelf.

Tanekashi-sama was then a talisman to insure fertility of seeds for agricultural use, but in the passing years this theme has been subverted to mean not agricultural seed but "human" seed. It is now considered a charm effective to promote human fecundity.

The doll is fashioned after a red and white garmented kneeling miko (shrine maiden) in whose arms nestles a small child. Women desiring a baby purchase one of these small painted clay statues and present it to the shrine along with fervent prayer for the success of their wishes. And so the small sanctuary dedicated to the god of agriculture is today literally staffed by a host of tiny miko in the form of prayerful tanekashi-san holding babes-in-arm. Traditions die hard in Japan and those that have to change, do so in a way that make their continuance even more charming.

HONGYO-YAKI

Seto history goes back far enough for that area (the district surrounding Seto and Tajimi) to be styled as one of the Rokoyu or Six Ancient Kilns. The others are Shigaraki, Echizen, Bizen, Tamba and nearby Tokoname. Four continue to make unglazed wares while glazed Tamba is of fairly recent origins. On the contrary, though, glazing is and was almost from the start a very important part of ceramic tradition in the Seto-Tajimi locale.

The number of different types of ceramics made within a 50-kilometer radius encompassing these two towns is staggering. Besides porcelain, which today accounts for most of the output, there are at least a dozen other types of earthenware (toki) including one definitely classified well within the framework of mingei: HONGYO-YAKI.

The current master, Mizuno Hanjiro, is the sixth family head to operate the kiln, which began production in the late Edo era. His maki-gama, called "Hanjiro-gama," is a massive, four-chambered nobori-gama with three frontal firepits. Recent acclaim has forced the potter to add minor firings in a much smaller single-chamber kiln to the annual major firing of the main kiln. Five potters in addition to the master are busy year-round to complete enough works to fill the roomy chambers.

Works are unsigned in true mingei style, but characteristic coloration quickly identifies their source. Clay used for Hongyo-yaki is collected from the Seto hills and refined for potting at the Hora workshop. Glazes are of several varieties including the green of Oribe, a dark brown Ame, and Kiseto yellow. Gozu blue and a dark-toned orange are also shades used frequently, often in tandem with two or more others. Glazing is often placed about the upper portions of the piece being fired. Dripping patterns occur almost accidentally to create an identifiable style. The transparent overglaze used has a distinct greenish overtone.

Hongyo wares resemble no others in the area and few mingei kilns even produce similar wares. See the color plate on page 124 for a sample of this ware.

WASHI

Handmade Japanese papers—WASHI is the general inclusive term—have been the focus of several major recent publications and were a focal point for the International Paper Conference held in Kyoto in early 1983. Delegates to that weeklong event were treated to a wide variety of demonstrations concerning manufacture of paper in all its dimensions. One came away with a sense of having missed a great deal in the world of craft for having paid but scant attention to papermaking activities.

The process in general requires raw material from one of three native plants: ganpi, kozo (a mulberry relative) or mitsumata. The basic materials are harvested in late autumn after leaves have fallen. Bark is stripped from the core wood by first steaming and then immersing it in cold water. Before being dried in bundles, inner and outer bark must be separated, either by hand (with a knife) or by flailing. Wood ash or caustic soda in weak solution is then used to soften and separate the fibers before they are washed to remove all impurities. Cleaning helps ensure long life for the finished product, so one final washing of the long fibers is done before it is pulverized by beating.

The pulp in a water and mucilage solution is ready for making sheets of paper by either of two methods. Tamezuki or mould-dipped sheet production allows single sheets to be produced easily, in comparision to the nagashizuki method, which requires the mould to be moved almost constantly to make even and strong sheets of fiber-intertwined papers. This method makes stronger paper.

Each wet sheet, after slight draining, can be peeled from the screen-mould and stacked in a pile atop one another. The mucilage used to bind free fibers together is non-adhesive so the sheet will not stick to one another even after the stack has been thoroughly pressed. Each sheet is peeled off the pressed pack independently and brushed flat onto a drying board before being put into the sun to dry. Sun drying adds both gloss and strength to the finished product. Each sheet is examined and cut to size when removed from these boards.

COLLECTORS SOURCES

There are a number of places in Tokyo and other major cities were one can find displays of folk art both old and new. The JAPAN FOLK ART MUSEUM (Nihon Mingeikan) at 4-3-33 Komaba, Meguro-ku, Tokyo,has perhaps the best-known collection. It is closed each Monday and not open during January or February or when exhibitions are being rotated. The collection, one of the largest and most important in Japan, was begun by the late Dr. Yanagi Soetsu who was its first director. All sorts of paintings, ceramics, textiles, lacquerware, toys furniture, metalwork and wearables from different eras and varied districts have been assembled along with some Ainu (Hokkaido) works, pieces representing the Ryukyuan (Okinawan) culture, Korea and the West. The museum is easily reached by train on the Inokashira line out of Shibuya. Exit at Komaba, the second stop. It's about five minutes walk from the station exit (tel: 03-467-4527).

The Okinawan branch of the Mingeikan is located at 1-30 Kanagusuku-cho, Shuri, Naha-shi, Okinawa-ken (tel: 0988-55-0248) and is open everyday except Tuesday and during the New Year season.

In Osaka one can visit the JAPAN CRAFTS MUSEUM (Nihon Kogeikan) at 3-619 Shinkawa, Naniwa-ku, Osaka, which is open daily except for Monday and exhibition changeovers. It is located handy to the Namba station of the Nankai train line (tel: 06-641-6309).

And lastly one might wish to see the JAPAN FOLK-LORE MUSEUM (Nihon Minzoku Shiryokan) in Nagano-ken at 4-1 Marunouchi, Matsumoto-shi. Closed only during New Years and changeover, it is adjacent to Matsumoto Castle which was constructed in 1504 (tel: 0263-32-0133).

The two shops whose owners are mentioned in my introduction are both handily located in Tokyo. Each has a wide and seasonally changing selection of folk art and handcrafted items from all over Japan. Collectors who haven't time to find items at their sources might wish to visit either of these fine stores:

- TAKUMI Craft Shop (President, Mr. Shiga Naokuni) 8-4-2 Ginza, Chuo-ku, Tokyo 104 (tel: 03-571-2017)

- BINGOYA Craft Shop (President, Mr. Okada Hiromu) 69 Wakamatsu-cho, Shinjuku-ku, Tokyo 162
(tel: 03-202-8778)

INDEX/GLOSSARY

Numbers 1 through 116 refer to specific chapters.
Capitalized index terms are also chapter headings.
Bold faced numbers refer to main chapter numbers.

Photo credits :

pages 113, 114, 115, 116, 117, 118(top), 119(bottom), 120, 121, 123(bottom), 124 & 136 - YOKOI Shigeharu

pages 127, 128, 129, 130,132 & 135(top)- SONOBE Cho

page 126 - courtesy of Hashimoto Yakichi Shoten, Saitama-ken

page 131 - courtesy of Tour Companion, Tokyo News Service Ltd.

page 135(bottom) - courtesy of Tateyama Shoko Kaigisho, Chiba-ken

pages 118(bottom), 119(top), 122, 123(top), 125, 128(inset), 133, 134 by author

Bingata material on page 122 - courtesy of Aoki Kimono Shop, Tokyo.

Folk-art objects on cover provided courtesy of Bingoya.

AMAURY SAINT-GILLES, a longtime resident of Tokyo, operates a gallery dealing in contemporary Japanese ceramics and avant garde prints.

This book served as a catalog for an exhibition of folk art that debuted in 1983 at John Wanamaker Philadelphia and is currently touring North America.

In addition to gallery endeavors, Mr. Saint-Gilles regularly contributes articles to a number of publications including weekly critiques on current exhibitions for the Mainichi Newspapers in Tokyo.

He has lectured around the world on ceramics and modern prints and leads collectors' tours to kilns and studios in Japan. In 1978 he published a guide to contemporary Japanese kilnsites under the title EARTH`n'FIRE (Shufunotomo, Tokyo) and at present is working on a third book.

Other Titles in the Tuttle Library of Art

THE ARTS OF JAPAN: AN ILLUSTRATED HISTORY
by Hugo Munsterberg

A history of Japanese crafts and fine arts from ancient times to the present. Through a stimulating and informative text illustrated with 121 carefully chosen black-and-white and color photographs, this book charts the various developments in and influences on Japanese art, particularly in the areas of painting, sculpture, architecture, and handicrafts.

ZEN ART FOR MEDITATION *by Stewart W. Holmes and Chimyo Horioka*

Emptiness and silence—this book is about the mind-expanding emptiness of Zen paintings and the reverberating silence of haiku poetry. Reproduced are thirty-one "landscapes of the soul," described by the authors as "transactions with the universe" that lead to the realization that "emptiness, silence, is not nothingness, but fullness. Your fullness."

CHINESE JADE THROUGHOUT THE AGES
by Stanley Charles Nott

A descriptive account of the significance and meaning of jade in Chinese culture, from the earliest times to the twentieth century. The text reviews the characteristics, decoration, folklore, and symbolism of this highly prized stone. Illustrated with over 350 photographs and line drawings.

ORIENTAL RUGS: A COMPLETE GUIDE *by Charles W. Jacobsen*

A thorough guide for anyone interested in purchasing an oriental rug, as well as the collector, curator, and rug importer. Acclaimed by experts as "the most comprehensive book on the subject," the text includes helpful hints as to what the rug buyer should look for in a rug; a list of all names used to identify rugs, with full descriptions and discussions; and 194 photographs of different types of rugs.

THE JAPANESE ART OF STONE APPRECIATION *by Vincent T. Covello and Yuji Yoshimura*

A concise introduction that offers aesthetic guidance and practical advice to would-be collectors and lovers of *suiseki*—small naturally shaped stones selected for their intrinsic harmony. Since the sixth century, the art has been refined in Japan, where stones of great beauty are set on stands to suggest distant mountains, soaring cliffs, and mystical islands. Over 165 illustrations and line drawings.

CHINESE SYMBOLISM AND ART MOTIFS *by C.A.S. Williams*

A standard reference work for students of China and Chinese culture. Arranged alphabetically for easy access, this book contains concise explanations of important symbols and motifs pervasive in Chinese and Oriental art. Also included are many short articles on Chinese beliefs, customs, foods, arts and crafts, agriculture, and medicine. Over 400 illustrations.

BATIK: THE ART AND CRAFT *by Ila Keller*

A comprehensive and fascinating account of the origins and history of batik, with examples of techniques and design and a how-to section on modern batik making. This book takes you through all aspects of the art—from a simple dipping to more intricate six-color patterns. Here is a text that gives all the "tricks of the trade." Lavishly illustrated.

CHINESE PAINTING TECHNIQUES *by Alison Stilwell Cameron*

Stroke-by-stroke instruction for those who have had no art training of any kind. Following an explanation of the physical tools of the art, the book starts the aspiring artist off practicing basic strokes and writing Chinese characters. From there, strokes are combined to form works of art after traditional Chinese styles and themes. Lavishly illustrated.

THE ARTS OF CHINA *by Hugo Munsterberg*

A classic text on the arts of China by a distinguished scholar and authority on Oriental arts. Dr. Munsterberg traces the history and development of Chinese artistic traditions as exemplified in ritual bronzes, sculpture, painting, and architecture, from prehistoric to recent times. With 116 illustrations.